African Americans
— I N —
MID-MISSOURI
FROM PIONEERS TO RAGTIMERS

ROSE M. NOLEN

Charleston London

THE
History
PRESS

Published by The History Press
Charleston, SC 29403
www.historypress.net

Copyright © 2010 by Rose M. Nolen
All rights reserved

First published 2010

Manufactured in the United States

ISBN 978.1.59629.609.1

Nolen, Rose M., 1935-
African Americans in mid-Missouri : from pioneers to ragtimers / Rose Nolen.
p. cm.
ISBN 978-1-59629-609-1
1. African Americans--Missouri--History. 2. African Americans--Missouri--Social life
and customs. 3. African American pioneers--Missouri--Biography. 4. African Americans-
-Missouri--Biography. 5. Missouri--History. 6. Frontier and pioneer life--Missouri. 7.
Missouri--Social life and customs. 8. Missouri--Biography. 9. Missouri--Race relations. I.
Title.
E185.93.M7N63 2010
305.896'0730778--dc22
2010039759

CONTENTS

DAYS OF INFAMY IN MID-MISSOURI

In 1803, President Thomas Jefferson bought from Napoleon Bonaparte the territory of Louisiana for $15 million. This was known as the Louisiana Purchase. When the United States took possession of the territory, the population was estimated to include nine thousand whites and three thousand Negros.

In 1804, Meriwether Lewis and William Clark were commissioned to explore the upper Missouri River to find its source. It was hoped that the explorers would find a water route to the Pacific Ocean. In 1812, Congress passed an act that named the new possession the Territory of Missouri. It was named for the Missouria, a tribe of Indians who peopled the state in the 1600s. Insofar as the French had introduced black slavery into the state about 1720, Missouri was admitted to the Union as a slave state on August 10, 1821.

One famous hunter had discovered the new territory in the late 1790s. Daniel Boone had walked from Kentucky to Missouri and settled near St. Charles. One of his expeditions had brought him into mid-Missouri, where he discovered a salt spring near what is now Howard County. Boone's sons started a saltworks at this spring. The area around that spring became known as Boone's Lick. That name continues to be popular in the area today.

Following the Louisiana Purchase, the rich, fertile soil of mid-Missouri began to capture the interest of southern planters. The new arrivals

found that not only was the land ripe for planting, the forests were also filled with game. Turkeys, deer, elk and other large animals roamed the wilderness, and smaller animals like squirrels, rabbits and partridges were also plentiful. They found streams filled with fish and a climate that was mild and healthful. So, new people, primarily from Kentucky, Virginia and Tennessee, began arriving in droves and settling the territory in and around the counties close to the Missouri River.

By the 1820s, some counties had begun to form. Howard County organized in 1816, Cooper County in 1818 and Saline and Cole Counties were established in 1820. Land from Saline and Cooper Counties was combined to create Pettis County in 1833, and Johnson County was separated from Lafayette County in 1834.

Since building homes and farming the land required much labor, many of the new settlers also brought their slaves with them. Missouri slaves performed a variety of tasks, from sowing and harvesting of hemp, tobacco, hay, oats, corn and other grains to carpentry, blacksmithing and general household duties. By 1840, Missouri's population had experienced unprecedented growth. By that time, it counted more than 300,000 whites and more than 55,000 blacks within its population.

How these slaves were treated, of course, depended on the attitudes and dispositions of their masters. The Federal Writers Project organized under President Franklin D. Roosevelt's administration collected two of the following former slaves' accounts in Missouri.

When Joe Higgerson was interviewed on August 12, 1937, he told of being born a slave on a farm in Boonville, Missouri, in 1845. At the time of his interview, he was ninety-two years old and a veteran of the Civil War. Higgerson lived alone, his wife having passed away many years ago.

According to his story, his owner's name was Higgerson, and his slaves were well treated, but he knew that this wasn't the case for many others. He told tales of one woman being sold away from her baby to a trader and shipped down the river, allowed only enough time to kiss the infant goodbye, and another trader who chained the slaves together until he put them on the boat—they always carried whips so they could crack them and see how far the slaves would jump to keep from being injured. And he remembered one occasion in which a boat load of slaves were being

carried down the river and got as far as Cairo, Illinois, when many of the slaves jumped overboard and drowned.

Higgerson said that when the Emancipation Proclamation was signed, his boss came out and read the papers to his slaves. (Missouri's slaves were not officially freed, however, until January 11, 1865.) On the day he was set free, November 23, 1863, he went to Boonville and joined the Union army. He served in the Twenty-fifth Corps of the Second Division (of the Colored Infantry).

Ed Craddock of Saline County spoke to the Federal Writers Project on July 26, 1937. He was born in slavery a few years before the Civil War, and so he was too young to remember the experience. He was told some of the stories by his father, who he succeeded as janitor at a public school building. Craddock's father had worked at the building since the 1870s. His father told him about the patrollers who worked in threes and who would flog any slave caught off his farm without a pass. Craddock was told about a Marshall, Missouri man who made his owner angry and was chained to a hemp brake and left outside to freeze—he froze to death for his punishment.

Craddock's mother was owned by the Marmaduke family, one of whom served as an early governor of Missouri.

Slaves, of course, worked morning, noon and night. They often faced unbearable hardships, and those in mid-Missouri were not spared. They were often separated from their families and suffered lashings and floggings, and many were half-starved. Some slaves went barefoot all year or wrapped their feet in whatever was available to keep them warm and uninjured.

Sexual exploitation of female slaves was a common practice. Many slave owners fathered children by their slaves. Sometimes this resulted in mothers being sold off and forced to abandon their children when the slave owner's wife became suspicious. It might also result in the female slave receiving favorable treatment. One mid-Missouri slave who also spoke to the Federal Writing Project had an unusual story to tell.

Sim Younger, who was interviewed on July 28, 1937, lived in Sedalia. He was born on May 17, 1850, in Independence. At the time of the interview, he was eighty-seven. Sim's father was Charles Younger, who was the grandfather of the notorious outlaws known as the Younger

Brothers—Cole, Bob and Jim. At one time, these young men partnered with Jesse and Frank James. In 1821, Charles Younger operated a canoe ferry across the Missouri River from Randolph Bluffs to what is now Kansas City. Sim's mother was a slave, Elizabeth Simpson. He had one sister named Catherine.

Sim was five when his father died. Under the terms of Charles Younger's will, Sim, his mother and sister were among a group of six slaves who were to be set free upon his death. The family was also left a three-hundred-acre-farm in Jackson County. The will further stated that upon his death Catherine and Simpson should be known as Youngers and that the executor should remove the two children to a free state and place them in a respectable school, where they would be well clothed and cared for.

Apparently, his father's wishes were carried out, and after serving with the Ninth Army Corps in the Union army, Sim graduated from Oberlin College in Ohio in 1870. According to his story, his brothers and sisters were living at the farm at that time.

When blacks in mid-Missouri were emancipated, many remained on the farms, where they worked to become paid employees of their former owners, while others immediately departed for cities, where they could look for work. Some former slaves chose to build settlements on which they could form their own communities. There were several small settlements in central Missouri, such as Mount Moriah in Cooper County, Colorado in Pettis County and Three Creeks in Boone County. Settlements such as Mount Olive in Johnson County grew into sizable communities.

One of the original settlers in Mount Olive was Robert Collins. Collins was born a slave in Virginia. Collins was the name of the family who brought him to Missouri. When slavery ended, Robert Collins was one of those who decided to remain on the land he had worked as a slave. According to Gertrude Collins Murrell, who continues to live near the old settlement, her great-grandfather made a deal with a white farmer to obtain a home. He agreed to work for the farmer for eleven years at $100 per year, after which he could buy the land. Mrs. Murrell says that her great-grandfather then, in the 1880s, borrowed

money from the Concordia Savings Bank to purchase the 280-acre farm. John Collins married Jane Hughes after he came to Missouri, and they had eighteen children.

Other black families quickly joined the Collinses, until there were nearly a dozen black-owned farms in the area, along with many other homeowners. In their heyday as a thriving community, the settlement families had their own threshing crew, logged and had their own sawmill, where they produced lumber. In the more than one hundred years of its existence, the community had two stores, a restaurant, a garage and a service station. It also supported a horse trainer and several midwives.

The first church was established in Mount Olive in 1875. It was the Mount Olive CME Church. That building was replaced in 1914, and a third building was constructed in 1955, renamed Mount Olive Community Church and served the community until 1966. The Mount Olive cemetery, with its first recorded burial in 1900, lies behind the church.

The Foster School was built in 1923. Both of these buildings were constructed on land given to the community by one of the white landowners in the area. There were several white settlements in and around Mount Olive. Foster School burned down in 1930, and while school was held in the church for some time, another school named the East Lynne School was built a little over two miles from the old building in 1931. Between twenty-five and thirty children attended this school. Gertrude Murrell recalls that in spite of the fact that the school had no plumbing or lunch program, and the books they had were hand-me-downs, she enjoys fond memories of her days at East Lynne School.

The small community had a lively social life with its Old Tabernacle picnic area and several dance floors located around the community. And there was the Ladies Aid Society, which was active in sewing, gardening and other worthy projects for sixty years.

Although many of the black farms are rented out today, as some members of the original families have passed on and others have moved away, some of the old families, such as the Collinses, have members who remain in the area. The old buildings that once dotted the landscape have been cleared away, but many years ago a cemetery association was formed to keep that area clean and free of litter. And for people like

Gertrude Murrell, memories still linger close to the heart.

Mount Olive and the families who built the little settlement may be gone, but their efforts will live on in history. These people made the best of what life gave them. Good work doesn't get any better than that.

Pennytown in Saline County, eight miles southeast of Marshall, was another black settlement that gained a sizable population. At one time, it counted two hundred residents in its midst. Although the last resident of Pennytown, Francis Spears, passed away in 1979, former residents and their descendants continue to gather at the Pennytown church each August to celebrate "homecoming." Mr. Spears's niece, Virginia Huston, is one of a group of descendants who keep the history of Pennytown alive. The annual celebrations began about 1953, initiated by Reverend Richard Lewis, Mrs. Nellie Jackson and Mrs. Dorothy Williams.

The town was founded in the early 1870s by Joseph Penny, a freeman who came from Kentucky. He paid $160 for eight acres of land. Over the years, other members of the community purchased more acreage: ten more parcels, averaging six and a half acres each. By 1879, these plots added together made up the sixty-four acres that was known as Pennytown.

The members of the community produced their own food, had a blacksmith and shared other responsibilities to maintain the settlement. Older family members supervised the children while their parents worked. In 1886, one of the white landowners in the area permitted the people of Pennytown to build a frame house of worship on the property, and the Pennytown Free Will Baptist Church was established. The church's trustees purchased the land for twenty dollars in 1894. In 1924, the church burned down, and a new church was built to replace it.

Virginia Huston, who now lives in Marshall, was the last child born in Pennytown in 1944. Her parents, Josephine and Clarence Lawrence Sr., like the other residents of the town, moved from the community while she was still an infant. Still, Huston says that she has vivid memories of seeing the town when there was more activity there because her aunt, Willa Spears, worked in Marshall but still lived in Pennytown. Although on many occasions, the woman walked the eight miles to work, Huston's

parents took her home in the evenings. So, growing up, she spent many pleasant hours there.

It was Huston's mother, historian Josephine Lawrence, who worked faithfully to get the hamlet on the National Register of Historic Places. It was added to that list in 1988. By that time, the church had fallen into a state of disrepair. With the assistance of the Missouri Department of Natural Resources, renovation of the structure began in 1992, and work was completed in 1996. Huston feels a great sense of satisfaction now that the project is completed. Before her mother passed away, she had asked her daughter to see the work through to completion.

The church and the Finnis Creek Cemetery—which is located nearby and where many former members of the church are interred—are taken care of by an executive board made up of those associated with Pennytown. "They work hard and diligently to maintain the legacy which has been passed down. I pray that the young people coming along will continue to maintain them," Virginia Huston added.

The group's website can be found at www.pennytownchurch.org.

Since African Americans in Missouri continued to be enslaved during the Civil War, and since Missouri was a greatly divided border state, the question of whether slaves should be allowed to serve in the Union army was a source of debate. When a special state convention was held in 1861 and secession was opposed, the state's slaveholding governor, Claiborne Jackson Fox, who was a Southern sympathizer, took his family and his slaves out of the state.

On July 31, 1863, President Abraham Lincoln ordered that able-bodied black men between the ages of twenty and forty-five would be allowed to enlist. Slaveholders were paid $300 if a slave volunteered and $100 bounty for each slave who enlisted. As a result, seven black Missouri regiments served in the Union army. When the fighting ended, the Missouri state legislature in 1865 passed An Ordinance Abolishing Slavery in Missouri. It was the first state in the nation to do so, and Governor Thomas Fletcher signed a Proclamation of Freedom on January 11, 1865.

Mid-Missouri has a rich and poignant African American history in the state. When the long, dark night of slavery brought forth the dawn of

emancipation, the newly free people gathered their families and moved forward into the bright new day. African Americans have made many great contributions to the state and the nation.

They are proud to be Missourians and Americans.

THEY MADE A HOME
AWAY FROM HOME

Chester Himes and John Anderson

A MAN OF MANY MOODS: CHESTER HIMES

If you mention the name of his most popular book, *If He Hollers Let Him Go*, most older African Americans in mid-Missouri will probably recognize the title. Ask them the name of the author, and chances are their faces will go blank.

He was a complex man who lived a flamboyant life. He used the stuff of his varied experiences to create the action-adventure novels and other tales that were to assure him a place among the country's most prolific writers. His name was Chester Himes, and he was born in Jefferson City, Missouri, on July 29, 1909. His father, Joseph Sandy, was chairman of the mechanical arts department at Lincoln University, then called Lincoln Institute. Himes was one of three sons who grew up in a troubled home that set the stage for his tumultuous life and his storytelling.

To say that his parents were mismatched hardly describes the situation between the couple. As one travels through some of the details of their stormy relationship, it is difficult to understand how these two managed to ever get to the point of marriage. The father, Joseph Sandy Himes, was a mild-mannered, dark-skinned, blue-eyed man who did his best to avoid conflict at all costs. He was the son of poor black parents from

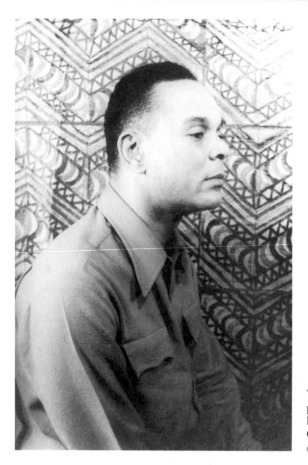

Young Chester Himes, a prolific writer, poses here for his friend, the photographer Carl Van Vechten. *Courtesy of the Library of Congress.*

North Carolina. He never knew the first name of his father. He was fourteen when his mother died, and he was brought up by an older sister, Leah. Somehow, he and his sister managed to get a college education. He graduated from Claflin College in South Carolina and became a teacher. By the time he married Estelle, he had become an instructor of mechanical skills. Even though he was raising a young family, he apparently never felt secure in his teaching positions. He left his positions abruptly, without explanation, forcing the family to move from place to place. Their family life was one where it seemed that they barely got situated in one location before they had to pack up again and move.

Estelle Bomar Himes, the mother, was proud of the mixed ancestry that gave her fair skin, gray eyes and auburn hair. She was born to an upper-

class family. Her father and brothers were successful builders who had constructed the first large cotton mills in Spartanburg, South Carolina. She had received her education at a parochial school, where she later taught prior to her marriage. Following her marriage to Joseph Sandy in 1901, the two joined the faculty of Georgia State College in Savannah. Their first son, Edward, was born there. Failing in her attempt to use her looks and her connections to gain Joseph an administrative position, they left Georgia State and moved first to Greensboro, North Carolina, and then in 1908 to Lincoln Institute, where Joseph Himes obtained a faculty post. Their other sons, Joseph and Chester, were born there. Estelle wanted the best for her children and did everything she could to see that undesirables whom she considered beneath their level did not taint them. She was overprotective and considered white culture superior to black culture, and she sought to instill this attitude in the minds of her children. Chester was her favorite son, and she was the dominant partner in her marriage.

Chester grew up in Jefferson City, where his family lived in a nice home. The Himes boys got along well and enjoyed playing together. They were not allowed to play very often with other children in the neighborhood, since Estelle thought the other children culturally inferior to her children. Her complaint was that they did not speak good English. Nevertheless, the family appears to have enjoyed a pleasant life. The fact that their neighbors were the college president and other members of the faculty pleased Estelle.

Suddenly, in 1913, Joseph Himes resigned his position at Lincoln. This was the beginning of a pattern that would govern the family's lifestyle for years to come. The family moved to Cleveland and joined the household of Joseph Himes's newly married sister, Leah. Soon, Joseph secured a position at Alcorn College in Mississippi. Although the college was situated in a remote area, the family was provided a large home, and Estelle gained domestic help. The family was able to participate in a variety of social activities with other faculty members, and they enjoyed a satisfying life. Since there were no public elementary schools, the family's living room became a classroom, where Estelle taught her children until they were about ten years old. Their schoolbooks were the classics, which

their mother ordered through the mail. The Himeses excluded militant Negro newspapers from their reading material. As Estelle sought to remove any vestige of blackness from Chester's appearance, as well as his thinking, he began to develop anger over his mixed heritage. Joseph taught his boys carpentry and how to use tools and machinery. As a consequence, the young men had all the elements of a well-rounded educational experience.

In 1917, Estelle accepted a teaching position in a missionary school in South Carolina. She took the two youngest boys, Joseph and Chester, with her. It was not a happy experience for Estelle. She felt isolated in Cheraw, where they lived, and it rained constantly. She left after a short while and joined her two nieces, who taught in a Presbyterian missionary school in Augusta, Georgia. Many of the students there were "Geechies," pure-blooded descendants of Africans slaves from the Georgia Sea Islands. Estelle was able to obtain a temporary job on the music faculty, and Chester and Joseph were able to attend school with the other children. They were placed in the eighth grade. This was a new experience for the boys, since for the first time they were able to enjoy the association of other children. The following year, though, they returned with their mother to Alcorn. One change was that Edward had left home and was attending Atlanta College.

The boys' school experience back in Mississippi was altogether different than it had been in South Carolina. Their light complexions bought them ridicule and mean-spirited taunts from their darker schoolmates. They fought as a duo and were constantly challenged. That experience came to a halt when the school term ended, because their father again suddenly resigned from his job. Their next stop this time was St. Louis, where their father had purchased a house as a rental investment.

The Branch Normal School in Pine Bluff, Arkansas, soon hired Professor Himes. Estelle was hired as a teacher in the public schools. The boys once more suffered racial taunts, and their route to school carried them through the slums, where they were subjected to prostitutes and other low forms of humanity. The family experienced the most traumatic event of their lives on Joseph and Chester's graduation day in June 1923. Joseph was exhibiting his mastery of chemistry before an audience.

Chester, who normally assisted him, remained at home because of a conflict with his mother. Joseph was demonstrating how gunpowder was made. Somehow the gunpowder exploded in Joseph's face, and he was instantly blinded. He was rushed off to Barnes Hospital in St. Louis. Once again, Professor Himes suddenly resigned his position at the end of the year, and Chester returned to St Louis with his father.

How much of this vagabond lifestyle, engineered by his father's inability to stay put, and the racial turmoil his mother continued to stir in his mind was responsible for the helter-skelter life that Chester Himes ultimately lived can only be imagined. His unpublished autobiographies and his two-volume set *The Quality of Hurt* and *My Life of Absurdity* seems only to add to the mystery. In any case, life for Chester Himes was definitely not a "bowl of cherries."

Things had not gone well for the Himes family in St. Louis. Professor Himes had not been able to get a teaching job, and he worked part time at odd jobs. His inability to earn a steady living was a source of irritation that Estelle made no effort to conceal. By 1925, the family was once again in flight—this time to Cleveland, Ohio, where Professor Himes's siblings lived. The Himes family moved in with his sister Fanny Wiggins and her husband. Estelle disliked living with the Wiggins, and she moved out of the house, taking Joseph, whose condition had improved, with her. Once again, Professor Himes, acting on his own, purchased a house in a middle-class neighborhood near the school where Joseph and Chester would attend.

The tension of living in a household that was constantly in a state of change, with parents that were frequently at each other's throats, was beginning to influence Chester's attitude and behavior. Furthermore, he felt that the security he had once experienced as his mother's favorite child had been stripped from him and that all the attention now shifted to Joseph because of his accident. Chester was becoming rebellious and belligerent. But because he had taken many college preparatory courses in high school, he was able to graduate midterm in 1926 a year ahead of his brother.

Out of school early, he began job hunting. One of his uncles helped him land a job as a busboy at the Wade Park Manor Hotel. What at first looked like a piece of good luck in an instant became a tragic experience.

He was removing a tray of dirty dishes from room service and thought that he was exiting through an open elevator only to realize too late that he had fallen into an elevator shaft. He suffered severe injuries, including one arm nearly broken off at the wrist, a broken jaw, lost teeth and three fractured vertebrae. He had to spend four months in the hospital, mostly in a body cast. He was forced to wear a back brace for the rest of his life. The income from his disability, which was seventy-five dollars monthly, supplemented by a stipend from the hotel enabled Chester to enroll at Ohio State University. As bright as his high school record made him appear, he was a poor student at college. That fact, added to his attraction to whorehouses—where he spent much time and encouraged others to join him—his drinking of bootleg whiskey and his engaging in sexual forays, resulted in his being placed on academic probation in December 1926.

During his probation, Chester resorted to a life of drinking, whoremongering and hanging out with questionable associates. His unhappy parents failed to discipline him, and he drifted further toward criminal activity. His brother Joseph, in the meantime, had graduated from high school with high honors, which won him a full college scholarship at Oberlin College. Chester's principal activities became pimping and stealing, and when he stole a student's identity card and forged several checks to purchase clothing in department stores, he was apprehended and sentenced to five months' probation. A short time later, he and some friends burglarized a Cleveland YMCA where National Guard ammunition was stored. A plan to sell these guns went awry, and a shootout occurred; Chester was arrested again, this time receiving a suspended sentence. It was during this period in his life that he met seventeen-year-old Jean Johnson, an attractive black woman whom he would ultimately marry.

His parents had finally divorced by the time Himes's life of crime escalated. Chester overheard a chauffeur bragging about where his rich employer kept his money and jewelry. On the chauffeur's day off, Chester was waiting for the man and his wife to return home, and he met them with gun in hand and robbed them of more than $300 in cash and $5,000 in jewelry. Himes then caught a train to Chicago and attempted

to pawn the jewelry with a fence. The fence went into a back room and phoned the police. Himes was arrested, beat up until he confessed and was returned to Cleveland, where he faced the charges. He pleaded guilty and was sentenced to twenty to twenty-five years in Ohio State Prison.

Himes began serving his sentence in December 1926. He was given a job carrying mill shavings to the basement for use in heating the prison. One act of refusing to follow orders earned him the kind of beating that should have persuaded him against openly resisting orders again; nevertheless, his rebellion continued, and he suffered beating after beating. On Easter in 1930, a fire set by convicts engulfed the building and killed more than 330 inmates. Himes luckily escaped harm, as other prisoners broke down doors to assist their fellow inmates. It was a tragedy that Himes would never forget. He spent much of his time reading law and writing letters to the governor requesting appeals. He fell in love in 1933 with a black man from Georgia, Prince Rico, and the two shared a homosexual relationship until Himes was transferred the following year to London Prison Farm. Rico was interested in work and prison songs, and both wrote and collected them. He and Himes shared their creative interests. They read loudly to each other, wrote a play and an opera together and shared interests in movies and authors. When they were separated, they wrote to each other for a time.

In 1931, Himes began to write fiction. He first published with black publications such as the *Pittsburgh Courier* and the *Atlanta Daily Word*. By 1934, *Esquire* magazine was buying his stories. In these stories, his main characters were white, and his own race was never revealed. Himes's stories were loosely based on his own experiences.

On April 1, 1936, Himes was released from prison into his mother's custody. Estelle was living with Joseph in Columbus. His brother had earned a doctorate in sociology at Ohio State and was working for the Urban League. Himes, according to his own admission, rushed to the black slums to avail himself of prostitutes. He also renewed his associations with black criminals. One day, someone gave him some marijuana, and Himes, innocent to its effects, complained to his mother that he was having a heart attack. When a doctor came to treat him, he told Estelle the true nature of her son's symptoms, and his mother turned

him in to his parole officer. Soon after that incident, Estelle went back to South Carolina, and Chester moved to Cleveland to live with his father.

At the time, Joseph Sandy was a teacher for the Works Progress Administration (WPA), and he also had a female friend. He had little time or money for Chester. Chester continued to write for *Esquire*, but his disability compensation ended, and it became necessary for him to get a steady job. He was able to get work as a waiter at the Wade Park Manor Hotel, where he had formerly been injured. He was anxious to make a living as a writer and therefore made as many contacts as he could. One of his contacts was Langston Hughes. Hughes gave him some influential contacts in Hollywood and New York. In 1937, Chester took a giant step and married Jean Johnson, who had been faithful and loyal during his imprisonment. He was twenty-eight and she was twenty-seven. His mother failed to attend the wedding. She was turned off by Jean's dark skin and felt that the young woman was inferior to her son.

Chester finally found work with the WPA digging ditches and cleaning sewers. Frustrated with the work he was ordered to perform, he wrote letter after letter to state and local officials. Finally, he was promoted to a research assistant at the Cleveland Public Library. He later earned a writing position, turning out vocational bulletins. He wrote an article about the animosity between religious groups in the nineteenth century that placed him in conflict with a new supervisor, and he was demoted down to a research assistant once more. Consequently, he wrote a bunch of angry letters to officials, including one to President Franklin Roosevelt, protesting his employment situation. Ultimately, he got his writing job back and was transferred to another project.

Intending to seek work out of state, Chester petitioned the governor of Ohio in 1919 for restoration of his citizenship. In 1940, he wrote a series of pieces for the *Cleveland Daily News* and for a new publication named *Crossroad*. He took advantage of the formation of the Council of Industrial Organizations (CIO) to write and edit articles on the history of the CIO. That year, Chester began a custom that was to continue for the rest of his life. Following in the steps of his father, Joseph Sandy Himes, he began traveling from one place to the next, determined to establish his writing career. His journey began in New York, where he and Jean visited

his cousin, Henry Lee Moon. Moon gave a party and invited several celebrities for Himes to meet. Langston Hughes attended and through friends was able to get Chester and Jean jobs working for novelist Louis Bromfield. Himes was disappointed that he didn't get an opportunity to do any writing, but Bromfield had read and liked his prison manuscript and told Himes that he would try to get it published or made into a movie. So the pair followed Bromfield when he went to Hollywood to work on a movie. His inability to find work or publishers for his writings, combined with race relations in Los Angeles at that time, kept him angry and frustrated. It was only the training he had gotten from his father in mechanical arts that made it possible for him to work in shipyards and defense plants during the war years. Jean, on the other hand, was able to find work, first in a defense plant and then with the United Service Organizations (USO). This further irritated Chester, who felt that it was the husband's job to support his wife. Finally, in 1944, with the help of his cousin Henry Moon's wife, he succeeded in getting a grant to write his book. And for the first time, he felt that he had an opportunity to unburden himself and write what he truly felt.

If He Hollers Let Him Go, Chester's first novel, which many consider his best, is about a black man's experiences working in a racist defense plant during World War II. His writing is clearly autobiographical, bringing his own emotional experiences and his anger at the conditions African Americans were forced to live under in every aspect of their lives out into the open in the lives of his characters. When the book was published and released, Chester was disappointed at the reception his book received by reviewers. His erratic lifestyle did not improve. His financial situation continued to be a problem, as he and Jean moved through a series of minimum-wage jobs in various locations. As Jean usually fared better than Chester, this also seemed to take its toll on their marriage. He was constantly borrowing money from friends whom he had met along the way. He nevertheless continued to be ambitious about his work, and he started on his second novel, *Lonely Crusade*, in which he made an effort to show the critics of his first book that they were mistaken in their criticism. The second book also failed to get much attention. Chester blamed the

book's promoters. In 1952, he and Jean decided to separate. Chester's father Joseph died during this period.

In 1953, Chester sailed for Europe. He had made contact earlier with black writer Richard Wright and others who agreed to meet him in Paris. Through the publication of his two books, he had also gained an English publisher. He met a woman aboard ship and fell in love, and his episodic lifestyle began in Europe where it had left off in America.

Chester's fortunes began to change in 1957 when he met Marcel Duhamel, the man who had translated his first book into French. Duhamel also was a pulp novel publisher, and he convinced Chester to write a detective novel since the French had a passion for that kind of fiction. Undoubtedly, Chester was more persuaded when Duhamel gave him an advance, since he was in constant need of money. With the publication of *The Five Cornered Square*, Chester's two most famous characters were born: Detectives "Grave Digger" Jones and "Coffin" Ed Johnson. The two men were big, hard-hitting, violent detectives who worked the streets of Harlem. The book won France's highest literary award for a detective novel that year. Between 1957 and 1960, Chester wrote eight more books in the series. Three of these novels were made into movies. One of them, *Cotton Comes to Harlem*, produced in the 1970s, was directed by Ossie Davis and starred Godfrey Cambridge and Raymond St. Jacques. In total, Chester wrote seventeen novels, two autobiographical works and dozens of short stories. His agent, Rosalyn Trag, helped relieve him of his financial pressures by seeing that he received the pay for his work.

Chester gained in Europe the celebrity he sought for so long in America. The fact that he lived during a period in which racism was at its height, combined with his growing up in a racially conflicted household, severely damaged him. His two-volume autobiography, *The Quality of Hurt* and *My Life of Absurdity*, details the agony and pain that plagued him because of the circumstances under which he lived most of his life. In his work and his self-analysis, he laboriously struggled to define racism and its effects on the human psyche, both of the victim and the oppressor. His disagreement with many black writers may have stemmed from the fact that he seemed to feel that his emotional judgments, his overt sexuality and his lust for white women were common to all black males. He seemed

to think that his upbringing, for example, was the rule for black families rather than the exception that it was.

After years of separation, Jean and Chester Himes finally divorced in 1978. That year, he married Lesley Packard, a white Englishwoman with whom he had been involved since the early 1960s. Packard was a librarian and a columnist for a New York paper. The two lived in Moraira, Spain. Himes's health began to decline in the 1970s. He died on November 13, 1984, of complications from Parkinson's disease.

A LONELY VOYAGER: JOHN ANDERSON

Mid-Missouri's slaves used a variety of measures to escape bondage. Some made spectacular escapes, as did William Wells Brown who after numerous failed attempts accompanied his new owners, a steamboat-owning family, on a trip to Cincinnati, stepped off the boat and never returned. Others fled by way of the Underground Railroad, which reportedly had several depots in Missouri. Though John Anderson's escape was even simpler still—he took off on a mule—his run for freedom ultimately made headline news in three countries. Author Patrick Brode describes this breathtaking adventure in intricate detail in his book *The Odyssey of John Anderson*.

According to the story, it was done in the name of love. In the 1850s, John fell in love with Maria Tomlin. Maria was a slave widow, the mother of two children. Her father was a free black man who owned a barbershop in Fayette, Missouri. Maria remained a slave because her father was still in bondage when she was born. Since slaves were considered chattel, she was still owned by the slave master. The two were married according to slave custom, and John agreed to work to earn enough money to free his wife and her children.

John was himself a slave and the son of slaves. He was born on the tobacco farm of Moses Burton in Howard County. John's father, a mulatto, worked as a steward on a steamboat. He escaped shortly after John's birth. His mother was a rebellious slave who on one occasion turned on the owner's wife and pulled a swath of hair out of her head.

For this act of vengeance, she was sold to another owner, and John never saw her again. As an orphan, he was raised in the household by Mrs. Burton, along with the Burtons' two daughters. He was called Jack by the Burtons. When he became a teenager, he was sent to the fields to work. After he learned the work, he was put in charge of the tobacco crop and given the job of supervising the slaves. As a reward, John was given by Burton a one-and-a-half-acre plot to farm and sell his own crop.

Following the marriage, John and Maria became new parents. Under Burton's rule, John was only allowed to visit his family on weekends. John took to disobeying this rule and began to spend every evening with his wife and child. Burton did not take kindly to his slave's disobedience, and when he was unable to whip John with a rawhide or John refused to be flogged, Burton threatened to shoot him and was only restrained from doing so by his daughters. With the death of Burrton's wife, who favored John, the situation between master and slave continued to worsen, and finally Burton sold John to a Saline County farmer.

Anderson found his new owner meaner and far more cruel than Moses Burton had ever been. The other slaves showed signs of being deprived of food and being overworked. When Anderson asked permission to visit his wife, he was told that he would never be permitted to see her again. Another slave had told John about freedom in a place called Canada, and this was enough to make John Anderson determined to flee Missouri and try to reunite with Maria whenever he could. On a Sunday in late September, he took a mule and a piece of rope and set out to cross the Missouri River for Fayette to tell Maria of his plans.

The next day, he reached Fayette and told Maria's father, Lewis Tomlin, that he was running away. Tomlin agreed that it was probably best that he did and offered him a gun to protect himself. John refused the offer, saying that his knife would serve that purpose. He visited Maria and their child and set out again. Missouri slave owners in the 1850s were constantly troubled by fear of a slave rebellion. So many slaves by this time had escaped that the state legislature had passed laws that made it legal for whites to seize runaways and gain five dollars per head for their capture.

Now three days into his journey, Anderson was foolishly traveling during the day when a local farmer, Seneca Digges, accompanied by his son and

four of his slaves met John Anderson. Digges asked Anderson for the pass he needed to have when he was away from his farm, and John concocted a story that Digges could not swallow. The farmer told John to join his slaves for dinner. As John walked with the other slaves, he suddenly broke away and fled into the woods. Digges ordered his slaves to chase after the fugitive, and he promised the reward money to whoever captured him. A little while later, the slaves caught up with John and had him surrounded. John Anderson pulled out his knife and threatened the slaves, who moved aside. As John ran across the woods, he encountered Digges again and his son, who had been following the chase. Realizing that he would be captured, John stabbed Digges in the chest. As Digges tried to run away, he caught his foot and fell, after which Anderson stabbed him in the back. Anderson again fled the scene. This time, he went back to Fayette and told Maria what had occurred, and she urged him to leave immediately. That was his final farewell to the woman he loved. They never saw each other again.

It wasn't long before bounty hunters were out in full force trying to locate the fugitive. By this time, John was only traveling at night, but even then he was almost captured by a bounty hunter on two occasions. Anderson was trying desperately to get to the Mississippi River, where he hoped he could cross into a free state. He finally reached the river within two weeks and crossed into Illinois in a stolen boat. At the same time, his victim, Seneca Digges, was drawing his last breath.

Even though he was in a free state, Anderson knew that he was still in jeopardy. He was no longer facing a flogging; his attack on Digges could very well result in him facing a Missouri lynch mob. Walking the countryside, stealing food whenever he could, he eventually made it to Chicago, where he was able to get help from abolitionists, who paid his way to Detroit. When he reached Detroit, he crossed the river into Windsor, west Canada. Canada was deeply divided at that time, with the west side being primarily populated by English-speaking Protestants. French-speaking Catholics primarily occupied east Canada. In any case, John Anderson was no longer in the United States of America.

Anderson, having arrived in a country where fugitive slaves were not uncommon, was able to find work with the railroad, and he enrolled

in a school for fugitive slaves. A slave who had escaped from slavery in Kentucky operated this school. The man's name was Henry Bibb, and he also had established the Fugitive Home Society and founded a newspaper called the *Voice of the Fugitive*.

Anderson's freedom was placed at risk again when a sympathetic teacher at the school heard his story and wrote a letter to Lewis Tomlin in the hopes of reuniting Anderson with his wife. Unknown to the teacher, Lewis Tomlin had been accused of harboring John Anderson, lashed and made to leave the state of Missouri. Howard County authorities read the letter that the teacher sent. Fortunately, she had written a Michigan address on the letter. But in an effort to aid the fugitive, she acknowledged that Anderson was in Canada. By this time, the governor of Missouri had requested Anderson's extradition. His freedom threatened once more, Anderson moved farther from the American border, into an area where there were many fugitive slaves. He remained hidden for six years.

Not all Canadians approved of their country being a refuge for fugitive slaves. Many spoke out against the slaves and accused them of bringing violence and criminal activity into the country. Still, the blacks were taxed, served on juries and voted. And the Anti-Slavery Society of Canada was established in 1851.

During the time that he lived quietly in Canada, John Anderson had learned the trade of masonry, bought a home and had established a good reputation. Unfortunately, he had made an enemy out of a former friend with whom he had quarreled. This enemy informed the magistrate of the township where they lived that Anderson was a wanted man. The magistrate prepared the necessary document and forwarded it to the justice of the peace. The informant said further that an Officer Port of Windsor was familiar with the circumstances. Anderson was taken into custody and identified by Port, who incidentally had never set eyes on him before but only had obtained a warrant for his arrest in 1854. Due to a delay in the paperwork between the justice system of Canada and officials in Howard County, Missouri, Anderson had already been held in custody for four weeks and had been released by the time the Missouri officials arrived. Since the owner of the *Toronto Globe* newspaper was also a leading abolitionist, this newspaper kept the case of John Anderson

alive; the abolitionist movement was kept very well informed about the case and became mobilized to act.

Although Anderson had fled from his home and had relocated to another county, he was found and, in spite of his friends' threats to free him, was returned to Brant County to face justice.

Brantford was not exactly hostile to blacks, but many resented the presence of fugitive slaves. Missouri was offering a $1,000 reward for Anderson's capture. He was charged immediately with the murder of Seneca Digges, a charge which he never denied, but he defended the act as necessary in order to escape slavery. Anderson had been given lawyers, and the trial began. Witnesses, several from Missouri (including two of Digges's sons), were called. All of the witnesses testified against Anderson, and the case was closed. Once the governor general signed the proper documents, John Anderson would be sent back to face the Missouri justice system. Anderson petitioned the governor general, explaining his side of the story and pleading not to be sent back to America.

Canadians for and against Anderson argued the case heatedly. A decision was made by political leaders to send the hot-button topic of whether to extradite John Anderson back to the courts. A writ of habeas corpus was issued that compelled the sheriff to bring Anderson before the court. The judges were then required to decide whether Anderson was being legally held. In the meantime, the American State Department had requested that the British ambassador demand the extradition of John Anderson. This request was forwarded to the governor general of Canada. According to the secretary of state of the United States, a Missouri senator was under the impression that the prisoner was about to be released. The British learned that Anderson was being held until after the hearing. Insofar as British and American relationships were very tenuous at this point, the British thought that this information would be received well. Newspapers in America were fanning the flames of distrust by implying that the Canadians would not send John Anderson back. The plight of the fugitive slave's future was now being digested internationally.

It was in November 1860 that the fugitive had his day in court on the writ of habeas corpus. Anderson appeared before the three judges

who would decide his fate. A large gathering, made up of a large group of blacks and many white members of the antislavery group, was on hand for the verdict. The issue of what course to follow in the Anderson case was legally complex. Canada had passed laws restricting slavery in the 1790s. The British abolished slavery throughout the empire in 1833. The British were vehemently opposed to extraditing slaves. However, in 1842, the British had signed the Webster-Ashburton Treaty in an effort to establish order on the Canadian border. Article 10 of the treaty provided that in case of murder and certain other crimes a warrant could issue for the fugitive's surrender. Some British believed that any act committed by a slave to gain his freedom was justifiable. It was against this background of legal opinion and moral fortitude that the matter lingered.

On the day in late November 1860 that the chief justice had chosen for the judgment to be rendered, the co-mingled crowd of John Anderson's supporters were disappointed. The chief justice explained that while he had made his decision, the other two judges had not, so therefore the judgment would be delayed for two weeks. So it was on December 15 that the crowd under police guard gathered to hear whether John Anderson was to remain in Canada or be sent back to Missouri.

Each judge attempted to interpret the Fugitive Offenders Act of 1849 in his own way. The chief justice was the first to deliver his opinion, explaining that under Missouri law it was legal for Seneca Digges to attempt to capture a runaway slave, that murder was illegal in both Canada and Missouri and that fugitive slaves were not exempted under the Webster-Ashburton treaty—therefore Anderson should be expatriated. The second judge delivered a highly emotional opinion in defense of Anderson's act, citing the vicious nature of slavery. It was his belief that "natural law" had been violated and that under the law Anderson's behavior was justified. The third judge agreed with the chief justice, concluding that an escaped slave was no different than anyone else in his responsibilities to obey the law. When the last judge had finished speaking, Anderson's lawyer stated that he would file for yet another appeal, and once again John Anderson was carted off to jail.

In America five days later, South Carolina seceded from the Union, and the United States was on the brink of war.

The news about the plight of John Anderson was spread across the pages of newspapers in three countries. Speculation was ringing wild as to what the next episode in the saga would bring. The secretary of the Anti-Slavery Society of Canada contacted the secretary of the British and Foreign Anti-Slavery Society and requested help in trying to bring the matter to a successful conclusion. The secretary of the British group, operating on his own, contacted a wide range of individuals and organizations, urging them to write to the colonial secretary and urge him to meet with the antislavery groups. The British public was clearly on the side of the defendant in the case, and many newspapers in their editorials pleaded John Anderson's case. Many of them did not hesitate to berate the Canadian judges for their decision. So powerful was the public's influence that the colonial secretary in 1861 told the governor of Canada not to extradite Anderson—he reminded the governor that extradition was an administrative function and not a judicial one.

Finally, in a desperate move to save Anderson's life, a lawyer suggested to the British secretary of the antislavery group that the society should try to obtain a writ of habeas corpus from an English court. Upon the swift success of this idea, such a hearing was to be held in five days. A lawyer was acquired to present the antislavery group's case. He misled the judge in the case completely in the matter of Britain's relation to Canada regarding the matters of jurisdiction and claimed that the Canadian courts were in the control of the British.

In the meantime, the Canadians were incensed by the idea of English interference in their colonial affairs. Canadians felt strongly that the English were trying to override their Canadian courts. Some southern Americans saw Britain's intervention as a willingness to cooperate in returning any slaves. Fresh news of the Anderson case was now springing up on a minute-to-minute basis. When the news of British intervention reached the ears of Anderson's lawyer, he issued still another appeal. This time he appealed to the Court of Common Pleas. This appeal was then scheduled to be heard the following week. The attorney had reason to believe that he might have a better chance to prove the fugitive's case before this court.

On February 9, 1861, the Canadian Court of Appeals went into session. Maximum security was enforced, as the audience had gathered to witness

another contest in the war over the freedom of John Anderson. Both the defense and the prosecutor presented their arguments in much the same fashion as they had during the original trial. If either attorney expected the judges to agree with their side of the argument, they were wrong.

Much to the amazement and astonishment of the crowd, Chief Justice William Henry Draper and his associate judges instead questioned the prosecution concerning the warrant that had been issued to take Anderson into custody in the first place. The chief justice pointed out that the warrant required the magistrate to certify an offense and that Magistrate Matthews had not certified an offense. In fact, no offense was named at all. The word "murder" was never mentioned in the warrant. The justice went on to state that if the defendant had never been committed for murder or charged with the crime, on what grounds had he been arrested in the first place? The prosecutor attempted to convince the justices that the words "feloniously and maliciously did kill" was the same as "murder." Under questioning, the prosecutor admitted that the warrant was defective. Under the faulty wording, the phrase "feloniously and maliciously did kill" could be interpreted as having committed manslaughter or justifiable homicide. In any case, the original magistrate had improperly worded the warrant.

John Anderson had been seated in the semicircle usually reserved for Queen's Counsel when the court came to order on February 16, 1861. In his decision, the chief justice admitted that he had been in conference with the chief justice from the original trial after that justice had pointed out the defective warrant. The two had discussed the case. The original justice had pointed out another case in which the wording on the warrant was at fault and the defendant had been released. The two judges discussed the faulty document and decided that Anderson should be released. The chief justice admitted that had it not been for the defects in the warrant, he would have agreed with the original decision. When the verdict was announced to quash the warrant, the crowd yelled and stomped with enthusiasm. When Anderson was released, he said thank you to the judges and was led out of the courtroom. Although Anderson was temporarily a free man, he as well as his friends knew that another extradition warrant perfectly worded could still be served against him.

Not certain of what the future held, Anderson was invited by the London Emancipation Society to come to England. His Canadian abolitionists friends, fearful for his safety, urged him to go. He arrived in England in March. By mid-June, he was in Liverpool, where he was officially welcomed with a reception in Exeter Hall before an audience of six thousand. Following this, he toured across the country, telling his story in place after place.

Finally, his friends decided that he should stop lecturing and get some education. Anderson was sent to study at the British Training Institute in Northhamptonshire. When Anderson had learned to read and write, a member of the London Emancipation Society suggested that Anderson should be sent to the free black republic of Liberia in Africa. The idea was seized upon, and the proper arrangements were made. In December 1862, a farewell reception was held for Anderson in London. He received a grant of free land in Liberia and second-class passage on a steamer.

A few days later, Anderson was escorted to Eustace Station, from which he traveled to Liverpool. A friend saw him on board a ship. On Christmas Eve 1862, John Anderson set sail on the *Armenian* for Cape Palmas, Liberia, and was never heard from again.

His actual whereabouts following that report remained a mystery.

THE RAGGED MUSIC MAKERS OF MID-MISSOURI

S everal years ago, a decision was made to name the rooms of the University of Missouri–Columbia Memorial Union for famous Missourians. Room S222 was named in honor of two of Missouri's most famous musicians, J.W. "Blind Boone" and Scott Joplin. This was indeed a fitting tribute to the men who blazed the trail by creating the syncopated rhythms that came to be known as ragtime music. That both emerged from their lowly beginnings to become such notable figures in the field of music is remarkable.

While both men were geniuses, they were not alone in bringing the new music to the parlors and dance halls of the public. There were other bright, talented mid-Missourians who contributed to enriching the ragtime era. While mid-Missouri produced many of the gifted musicians, such as Arthur Marshall and Scott Hayden, it was St. Louis that offered the environment in which the music was able to grow.

"Honest John" Turpin's Silver Dollar Saloon in St. Louis could be called the birthplace of ragtime music. The saloon was located in the notorious Chestnut Valley sporting district of the city. The robust band of itinerant musicians who plied their trade in the lively towns that lined the river made Honest John's a stopping point. The place had a reputation for providing a good time, so it gained popularity among Mississippi

riverboat travelers who visited the area. As early as 1885, young Scott Joplin, who would later become the King of Classical Ragtime, worked as a café pianist at Honest John's for an eight-year stint.

Honest John's son, Tom, had a natural musical talent and had profited from formal music lessons. In 1897, at the age of twenty-four, Tom Turpin published the first of the ragged tunes, the "Harlem Rag." He owned the Rosebud Café in St. Louis.

Finding a publisher to put his tune in print had presented Turpin with quite a challenge. At first, the publishers to whom he sent his compositions were reluctant to print the strange new music. The music publishers claimed that the music was too difficult for the average musician to play. Still, Turpin continued to compose, and ultimately he found a publisher. In the early days of the twentieth century, Tom Turpin was one of the best-known ragtime composers and performers in Missouri.

He earned the titles "King of the Piano" and "King of Jazz."

In the mid-1890s, Sedalia was the center for black musical entertainment in mid-Missouri. The town, recovering from the money panic of 1893, had a youthful population of African Americans, and the community was well served by the railroads. People were coming and going all the time either to work on the railroad or to visit the town. There was a new, recently built black college with an outstanding music department that was just opening its doors. In addition, the town had a wealth of talented African American musicians.

Sedalia also had its share of dance clubs and bawdy houses, so in both black and white Sedalia there was usually a job for a piano player. It was home to the Queen City Concert Band, which was the most popular black band in the area and was seldom at a loss for engagements.

On Scott Joplin's first visit to Sedalia in 1894 with his two younger musician brothers, Will and Robert, the Joplins enlisted the assistance of five other local musicians and revived the Texas Medley Quartette, which they had formed in Texarkana. The Joplin brothers were born in Texas of parents Jiles and Florence Joplin, who were former slaves. Scott, who was the second son, was born in 1868. Jiles Joplin was a musician who played the fiddle and often played for dances in and around the town.

Sedalia's Ragtime Man

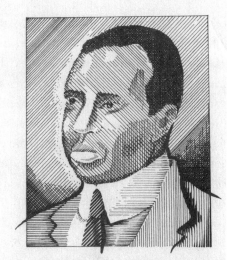

Scott Joplin
1868 — 1917

King of Classic Ragtime

A Scott Joplin souvenir. *Portrait by Dennis Murphy.*

Scott, constantly surrounded by music and musicians, was self-taught. His travels and stops along the way merely enhanced his natural talents.

The brothers hit the road with their quartet and traveled extensively throughout the country. While he was on the road with the quartet, Joplin had his first two pieces published by a music publisher in Syracuse, New York, and three more of his compositions were published in Temple, Texas. According to musicologists, of those five published songs, it was only the "Great Collision March" that reflected elements of ragtime. Scott Joplin was twenty-nine years old when the quartet played its last engagement in Joplin, Missouri. He returned to Sedalia, where he would live and work for the next four years.

Sedalia held another attraction for black itinerant musicians. Unlike the cities, such as St. Louis, African Americans did not reside in tenements or slum housing. They owned their own homes and lived in single residences. In Sedalia, Joplin resided for a time in the homes

of two of his future collaborators, Arthur Marshall and Scott Hayden. There is no evidence that he worked at anything other than his music. He played with the Queen City Concert Band in engagements of all kinds, including parades, and entertained groups on special occasions, such as at Emancipation Day celebrations. He performed in dance halls and bawdy houses, taught music to eager beginners and, according to some of his friends, studied music theory and harmony at George R. Smith College. Joplin enjoyed a friendship with black entertainer Tony Williams, owner of the Maple Leaf Club as well as the Black 400 Club, which opened doors of opportunity for Joplin to pursue. His first job, however, was in a white tavern at which the clientele was all-white. During this time, he was able to interest music publisher Carl Hoffman in his composition "Original Rags." Although Hoffman purchased the piece, he did not publish it until 1899.

Joplin completed the first draft of "Maple Leaf Rag" in 1898. After consulting his friends, he decided to rework the piece, and when he was satisfied with the results he began to look for a publisher. Joplin first offered the piece to Kansas City publisher A.W. Perry, who refused to accept the composition for publication. He then turned to Sedalia businessman John Stark, whose primary involvement in the music industry was tuning and selling pianos. One version of the Joplin-Stark agreement is that it was Stark's son Will, also as composer, who reportedly convinced his father to purchase the work. In any case, Joplin wandered into Stark's office and offered him the composition, and Stark accepted for publication Joplin's manuscript pages. Shortly thereafter, Joplin signed the five-year exclusive contract with John Stark & Son for the publication of the "Maple Leaf Rag." It was an occasion that would change the lives of both music publisher and musician.

While Scott Joplin was going about the business of publishing his most popular work in 1899, J.W. "Blind Boone" was enjoying the height of his success as a concert pianist. The tumultuous events that had plagued his early life had finally been put to rest. Under the guidance and management of John Lange Jr., Boone was experiencing the joy and satisfaction of the successful musical career that his genius deserved.

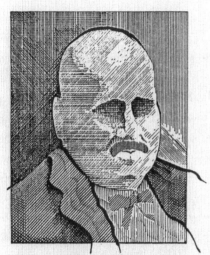

Columbia's Ragtime Connection

J.W. 'Blind' Boone
1864 — 1927

Composer, pianist extraordinaire

A J.W. "Blind Boone" souvenir. *Portrait by Dennis Murphy.*

The Blind Boone Concert Company was touring for ten months a year, from early fall to summer, and it had become a training ground for young singers, many of whom became stars in their own right. Melissa Fuell, who later wrote Boone's biography, began singing with the Boone Company when she was only seven years old. Much of what we know about Boone's life is based on interviews that Fuell had with Boone when she sang in the Concert Band; they were recorded and reproduced in her *Blind Boone: His Early Life and His Achievements.*

J.W. "Blind Boone" was born in 1864 in a Union army camp in Miami, Missouri. His mother Rachel Boone, a slave, had fled into Union territory some months before the Civil War, where she became a cook at the camp. The descendants of Daniel Boone, allegedly, had at one time owned Rachel. The identity of the father of J.W. is not known, and as was customary, the boy apparently of mixed parentage was given the last name of his mother. As an infant, Boone moved with his mother to

Warrensburg, Missouri, where at the age of six months he contracted what was called a "brain fever." In order to relieve pressure on his brain, doctors removed both of his eyes and sewed his eyelids shut.

In spite of this dreadful tragedy, his incredible talent for making music began when he was a small child. In Warrensburg, Rachel worked as a domestic servant in the homes of well-to-do families. She and her son lived in the homes of her employers, where her son acquired many white playmates. He had a natural inclination to repeat birdcalls, the sounds of other animals and people's voices, and when he received the gift of a tin whistle, he unexpectedly was able to duplicate these sounds, to the amusements of crowds who gathered around to listen to his musical offerings.

By his own admission to a Columbia newspaper reporter in the early 1920s, Boone organized his first band at the age of five. The band, of which he was the leader, consisted of two horns, two harmonicas, a drum and a comb. According to his story, Boone himself played a teacup-covered harmonica in the band. The band split up because of a dispute over money.

When Rachel Boone married Harrison Hendrix, who was the father of five children, the combined family moved into a one-room log cabin. News of Willie's (the name he was called by his family) talents spread like wildfire through Warrensburg, and a group of residents became concerned about the little musician's future education. When they approached Rachel Boone about their concerns, Rachel admitted that due to her financial situation she was unable to pay for her son's advanced education.

One of Rachel Boone's employers was Senator Francis Cockrell. Cockrell was one of the individuals who was interested in furthering Willie's education. So he convinced the county court to supply the young musician money for travel and incidental expenses, and some wealthy residents gave money to support him at the St. Louis School for the Blind.

Although Willie was blind, he was apparently quite well adjusted to his condition. While he loved being surrounded by an environment that enriched his musical talents, he hated being confined to classes. When he was finally allowed to play the piano, his restlessness diminished. He mastered the instrument in a short time and, as was often the case, his audiences were astounded by the range of his musical expertise. He further broadened his repertoire during the summer in Warrensburg by

playing at local events. His return to school was marred by the fact that the school's administration had changed and that the new environment was charged with racial prejudice. To escape the ill treatment, Boone began to sneak away at night and visit the Chestnut Valley district, where black itinerant musicians, like Scott Joplin, performed for black audiences. It was on these illicit night journeys that he was introduced to ragtime. He was ultimately expelled from the school because of his refusal to obey the rules.

Over the next few years, in his attempt to make a career in music Boone's life became fraught with a bag of experiences, some of them hair-raising. He was kidnapped by a gambler with a criminal heart who transported him across central Missouri to entertain at dance halls while depriving him of food and money and often forcing him to walk from place to place. Willie was whipped when he complained. Under this man, Mark Cromwell, he was exploited in the worst kind of ways. At one point, he was given to another man as payment for a gambling debt. Under this individual's ownership, he was locked in an attic for several days.

Cromwell persuaded him to rejoin him, promising him better treatment. It was not long before Boone realized that he had once more been tricked, but fortunately he was soon located by his stepfather, Harrison Hendrix, and with the assistance of police and friends, Boone was rescued and taken home.

Back in Warrensburg, it wasn't long before he was plagued by restlessness again. This time, his spirit of adventure led him back to the escapade he had used to earn transportation home from the school for the blind. He persuaded train conductors to allow him to earn his transportation by playing the harp and harmonica for the other passengers on the train. Other musicians caught onto this game, and many, pretending to be crippled or blind, began to beg their way on to trains to the point where the railroads had to end this practice.

Boone's next adventure led to him plying his trade in black churches in central Missouri towns such as Fayette and Glasgow. He joined a Methodist minister in Glasgow on a brief tour around the area. This minister introduced Boone to a Methodist minister in Fayette at whose church the young musician taught music and played for services.

J.W. "Blind Boone" poses while wearing some of his medals. *Courtesy of the State Historical Society of Missouri, Columbia.*

Boone's luck was about to change. A Christmas concert in Columbia, arranged by the pastor of Second Baptist Church at the time, was a prelude to Boone meeting the man who would be the most responsible for his impending success. The festival's organizer was the prominent black Columbia contractor John Lange. Lange, having gone into business in the 1870s, had earned his reputation by having built every road but one in Boone County at that time. After hearing an elaborate account of Boone's musical mastery from the pastor, Lange asked to be introduced. That meeting would lead to a successful financial partnership and a lifelong friendship between the two men.

About 1880, Lange became Boone's manager. Lange negotiated the contract with Boone's mother Rachel. Under the terms of this contract,

Lange agreed to arrange for Boone to have some additional formal music training. Boone's first assignment under his new manager was to perform in Sunday school for children.

At about the same time, Boone became an acquaintance of "Blind Tom." They met when Boone attended one of the pianist's performances. The prodigy, whose real name was Thomas Green Bethune, encouraged Boone to continue his musical career.

"Blind Tom" also had uncontrollable seizures and had to be strapped to his chair when he performed. He claimed through his advertisements that he could play seven thousand selections. As could be expected, a rivalry developed between the two. When "Blind Tom" had a concert in Columbia on March 3, 1880, John Lange brought the teenage "Blind Boone" to challenge him. Each pianist was able to duplicate the other's work immediately after hearing it. When the crowd seemed to favor Boone over Blind Tom, the two never challenged each other again.

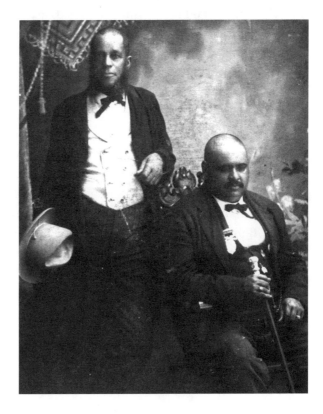

Longtime manager John Lange Jr. (left) stands beside his famous client and friend, J.W. "Blind Boone." *Courtesy of the State Historical Society of Missouri, Columbia.*

Lange fulfilled his promise to Rachel Boone, and her son went on to formal studies in music. He studied technique at Christian College in Columbia, where he was introduced to the masters, Bach, Beethoven and Brahms, with a private teacher who increased his repertoire by several pieces while he learned to interpret the classics; he later studied for about three years under the tutelage of a member of the musical faculty at Christian College.

Under Lange's guidance, Boone began touring around the Midwest. Initially, his tours did not go particularly well, and the band suffered from money shortages. Even when his fame spread, he experienced other hardships. Traveling did not always go smoothly for anyone in the early days of the century. In the first place, vehicles were not reliable. As the band for many years had to transport Boone's piano on a pulled wagon, getting from place to place could become quite complicated. If one happened to be African American, it was difficult in small towns, especially, to find adequate public accommodations. With the absence of fire departments and the lack of the availability of water, fire was always a hazard to be considered. The Blind Boone Company was subjected to several major conflagrations. Boone was also involved in two train accidents. Fortunately, he survived these tragedies unscathed.

With segregation a way of life, the band also had to often play two concerts in a town, one for whites and another for blacks. In cases where the audience was mixed, a special section had to be provided so that the races would be separated. While the audiences may have been separate, black music joined the classics across the piano keys under the talented fingers of J.W. "Blind Boone."

A concert by the Blind Boone Concert Company featured the great classics, Boone's own compositions and the popular music of the times. Many musicologists credit as one of Blind Boone's greatest contributions to the world that he was instrumental in bringing black music to the concert stage.

The Sedalia edition of the "Maple Leaf Rag" earned its composer, Scott Joplin, only four dollars in royalties in the first year of its publication. Sales suffered for the work due to the fact that the piece was difficult to play.

Syncopation was hard for some to learn. Nevertheless, the slow sales did not diminish Joplin's determination to continue to perform and compose.

He was performing regularly at the Maple Leaf Club and playing with his band. Following the publication of the "Maple Leaf Rag," Joplin composed his ragtime ballet, "The Ragtime Dance." By this time, Joplin had formed his own group, the Scott Joplin Drama Company. He rented the local theater, the Woods Opera House, for one performance of his new composition. John Stark refused to publish the ballet, even though it had received popular support. Stark, having relocated to St. Louis, finally published the ballet in 1902 as a song.

The rise in popularity of ragtime music was credited by some to the improvement in the pianola, which spawned the player piano. This advancement spiraled the syncopated music into the national spotlight. A rash of New York musicians began to publish ragtime pieces, and that form of the music became known as "Tin Pan Alley" ragtime. Their music was easily identifiable because of the "tinny" sound it created.

In spite of Stark's departure, Scott Joplin remained in Sedalia. Over the years that he had spent in the town, he had become a part of the community. Although with the publication of the "Maple Leaf Rag" he had achieved something of a celebrity status, he seemed to thrive on the relationships he had with the other Sedalia musicians. His companionship with Arthur Marshall and Scott Hayden would ultimately bear fruit in spirited collaborations.

Arthur Owen Marshall, in whose home Scott Joplin roomed early in his career, was born in 1881 in Saline County. Marshall was only fifteen years old when his teacher and friend came to live in his home. He was considerably younger than Joplin, and after attending elementary school in Sedalia, he continued his music studies at George R. Smith College. Marshall had a well-earned reputation as an outstanding local musician. Later, he traveled with McCabe's Minstrels.

Sedalia native Scott Hayden was born in 1882 and was a schoolmate of Arthur Marshall's. Like Marshall, he was a teenager when he became Scott Joplin's friend and student. In addition to his other musical talents, Hayden was also said to be a wonderful singer. Belle Hayden, his widowed sister-in-law, became Joplin's wife.

In 1900, Joplin collaborated with Arthur Marshall to produce "Swipsey Cake Walk," which was published by John Stark & Son of St. Louis. Joplin and Belle Hayden moved to St. Louis in 1901. Although the composition he produced with Scott Hayden, "Sunflower Slow Drag," was thought to be written earlier, it was copyrighted in 1901 and also published in St. Louis by John Stark & Son.

The years 1901 and 1902 were professionally fruitful though personally traumatic years for Scott Joplin. During those years, the following compositions were copyrighted: "The Augustan Club," "Peacherine Rag," "The Easy Winners," "I am Thinking of My Pickaninny Days," "Cleopha," "The Strenuous Life," "A Ragtime Two-Step," "The Entertainer," "A Breeze from Alabama" and "Elite Syncopations." His friends from Sedalia, Arthur Marshall and Scott Hayden, and his wife Nora roomed in the Joplin home, along with Joplin's brother, Will. Unfortunately, Will and Hayden's wife, Nora, passed away during that period.

In 1903, Scott Joplin began work on his opera, *A Guest of Honor*. His marriage to Belle Hayden, who was expecting their first child, was in trouble during this time. According to Arthur Marshall, Joplin complained that Belle was disinterested in his music career. The female child of the Joplins died in infancy, and the pair ultimately separated.

The Scott Joplin's Ragtime Opera Company of thirty-two members performed the ragtime opera once in St. Louis. While on a road trip, the company suffered a disaster when an agent for the company ran away with the receipts. At the same time, Joplin's trunk carrying the manuscript for *A Guest of Honor* was also lost. It has never been recovered. Near the end of the year, Joplin visited Chicago and produced "Palm Leaf Rag," which was published by a Chicago music publisher. The song version of "Maple Leaf Rag" was produced by John Stark that year as well.

Scott Joplin is thought to have written "Sycamore" and arranged for its publication before leaving Chicago. In any case, the year 1904 found Joplin back in Texarkana, Arkansas, visiting relatives. He also went to Little Rock, where he met his future wife. Back in St. Louis, in tribute to her, he composed "The Chrysanthemum" and dedicated it to her. He returned to Sedalia, where he soon found work in a dance hall. He found

lodging with the Dixon family, during which time he visited the World's Fair in St. Louis and composed "The Cascades" and "The Favorite."

In 1984, this period in the life of Scott Joplin was remembered well by one Sedalian. She remembered Joplin as the "young man in the brown suit and slouch hat" who once roomed at her grandparent's home at 111 East Cooper Street. Mrs. Lucile Martin's grandfather, Solomon Dixon, worked as a janitor at the Fifth Street Methodist Church and fired furnaces for several downtown businesses. In order to supplement their income, his wife took in roomers and boarders.

Mrs. Martin was four years old when she came to live with her grandparents:

> *My mother bought me an Emerson Square Grand Piano, because she wanted me to take music lessons as soon as I learned to read. Scott Joplin, as one of the boarders, used to practice on this piano of mine. My grandmother gave me permission to go and stand by the piano and watch Mr. Joplin practice, but she told me I was not to touch the piano. He would sit there and play for hours, and as long as he played, I would stand there and listen.*

As Mrs. Martin recalled, it was the other boarders in the house, rather than Joplin himself, who told her that he had composed "The Maple Leaf Rag." "That was the first time I head the name." She said.

According to Mrs. Martin, Joplin left Sedalia while he was living in the Dixon home to return to Texas. While he was away, he married. He brought his wife back and they lived together, sharing a room at the Dixon house. "But she was a very fragile person," Mrs. Martin said. "She may have been with us for about two years when she developed tuberculosis and died. Mr. Joplin took her back home to bury her, and when he came back, he was more restless, always going back and forth, in and out of the house. In the meantime, word had gotten around that he was working in collaboration with Alonzo and Scott Hayden and Arthur Marshall." (Freddie Joplin died on August 10, 1904. Actually, the Joplins had been married only ten weeks when she passed away.)

After the tragic death of Freddie Alexander Joplin, Scott left Sedalia and went to live in St. Louis in 1905. In 1907, he moved on to New York.

Scott Joplin died on April 1, 1917, at the Manhattan State Hospital of dementia paralytica, a condition brought on by tertiary syphilis.

During the early years of the twentieth century, the Blind Boone Concert Company continued to enjoy phenomenal success.

In 1889, Boone married John Lange's sister, Eugenia, further cementing their relationship. At one point, Lange hired white advance men as agents to assure that the band could adhere to a regular schedule. Eventually, he was able to hire a black agent for this assignment. Boone received rave reviews wherever he played. In addition to the performances for which he was paid, he always gave many benefit concerts. A popular feature of a Blind Boone concert was when he invited a member of the audience to play a difficult tune, after which Boone would repeat the piece without error. His popular composition "The Marshfield Tornado" was a regular selection at an event.

Disaster struck the Blind Boone Concert Band on July 21, 1916, when Boone's devoted friend and manager John Lange died. Boone was then the sole owner of the band, and he acted as his own head manager. He was assisted by a band member and her husband. And when the husband passed away, Wayne Allen, owner of Allen Music Company in Columbia, assisted Boone.

Although he continued to perform in the Midwest and even did an eastern tour that included Boston, New York and Washington, D.C., his fortunes were beginning to fall. He now had to compete for events in the field of entertainment with movies and radio. Bookings became difficult to secure, and he was also earning less money for his performances. Adding to his problems was a 1922 robbery of his home, at 10 North Fourth Street in Columbia, during which two rings valued at a little less than $2,500 were stolen.

In Boone's lifetime, his heavy hand ruined more than a dozen pianos. His last piano, a solid oak nine-foot concert grand, strung in England in 1891, was his one of his most valued possessions when he passed away on October 4, 1927. The piano, along with Boone's special watch, is on display at the Boone County Historical Museum.

Along with his other compositions, Boone also produced two ragtime pieces: "Southern Rag Medley No. 1: Strains from the Alley" and

"Southern Rag Medley No. 2: Strains from Flat Branch." Many of his compositions are preserved on piano rolls.

Together, J.W. "Blind Boone" and Scott Joplin brought the African American ragged sounds into the mainstream of American music.

CELEBRATING THE GIFTS

In the 1950s, Sedalians began to organize activities honoring Sedalia's most famous musician. Several concerts were held toward that end. Another concert was held in 1960 during the city's Centennial Celebration. The Scott Joplin Memorial Foundation was organized following the centennial. This group led the drive to erect the monument that currently stands on East Main Street at the former site of the Maple Leaf Club.

A local high school teacher and historian, Larry Melton, started promoting the idea of holding a ragtime festival. In 1973, the Sedalia Area Chamber of Commerce approved the idea, and the first ragtime festival was held that year.

It was decided by the festival group to begin efforts to bring about the issuance of a Scott Joplin Commemorative Stamp. That effort came into fruition in June 1983 when First Day of Issue ceremonies were held in Sedalia at the 1983 festival. Members of the Scott Joplin's family attended those ceremonies.

A Scott Joplin store was opened in the historic Bothwell Hotel at 103 East Fourth Street in Sedalia that sells sheet music and other ragtime items and also houses Sedalia ragtime memorabilia. In 1994, Kansas muralist Stan Herd was commissioned to paint a portrait of Scott Joplin at the piano on the north side of the circa-1880 Romanesque Revival–style building located at 205 South Ohio in downtown Sedalia.

On June 2–4, 2010, the Scott Joplin International Ragtime Foundation held its thirtieth ragtime festival.

J.W. "Blind Boone" is honored every year in Columbia with a Ragtime and Early Jazz Festival, which follows the Scott Joplin Festival. Many of the music makers that perform at the Joplin event also perform at the Boone festival.

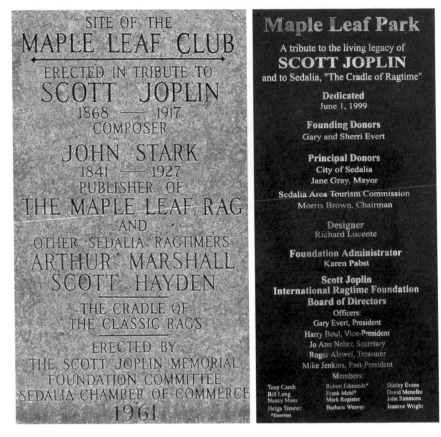

Above left: This marker stands at the former site of the Maple Leaf Club, where Scott Joplin entertained in the 1890s and early 1900s. It was erected by the Scott Joplin Memorial Foundation Committee in 1961. *Photo by Jeff Smith.*

Above right: This marker identifying Maple Leaf Park is affixed to the concrete structure on the former site of the Maple Leaf Club. The space is used for some performances during the Scott Joplin Festival. *Photo by Jeff Smith.*

Opposite top: Vivian McDonald (left) and La Erma White, grand-nieces of Scott Joplin, visited Sedalia in 1983 to attend the stamp ceremonies. *Courtesy of the Collection of Rose M. Nolen.*

Opposite bottom: The First Day of Issue ceremonies for the Scott Joplin stamp were held in Maple Leaf Park on June 11, 1983. *Courtesy of the Collection of Rose M. Nolen.*

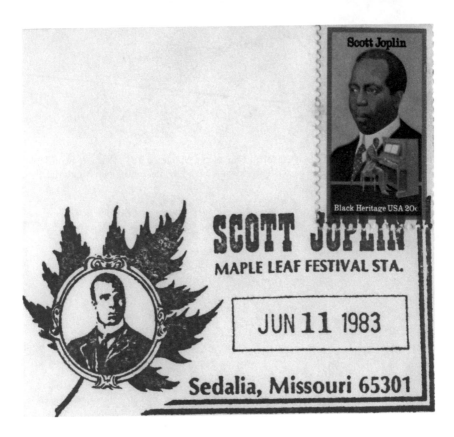

Texarkana, Arkansas
June 30, 1983

Dear Rose,

I'm sorry to be late in writing you, but as I told Alyce, I'm still floating around on "cloud nine" (smile)

First, let me thank you for a wonderful time. You and Alyce were simply great. Our trip would not have been the same if you had not been there. Our new found friendship seems as if its been there for a long time. We'll always cherish it.

The articles that you've written were all fanstastic. You're doing a fine job. As I forestated, I'm busy compiling me a scrapbook of all the activities of the festival. Its really nice if I do say so. I have all the important information on Scott Joplin at my finger tips. Now when my grandchildren want to know certain things about Scott Joplin

I can go to my scrap book and find anything that I need. Maybe, you'll get a chance to see it when (if) I get back to Sedalia. I tried to get all of the most important things. I found this article which I thought was very interesting. It reads —
Editors Note — The Times gratefully acknowledges the effort of Rose Nolen who kindly wrote the article on Scott Joplin. Her insight offers an element which, the Editor feels, is most important and may have gone unrecorded had it not been for her efforts
 Editor
Well Rose, they may not give you the proper credit and recognition that you so thoughtfully deserve, but in my book, you're tops. Keep up the good work.
 Love
 Lillian

This page and opposite top: Letters from members of the Scott Joplin family after their attendance at the stamp ceremony in Sedalia in 1983. *Courtesy of the Collection of Rose M. Nolen.*

July 29, 1983

Dear Rosa,

Your article on the Joplin Family was delightful. Your writing can hold my attention any day (smile). We are still remembering with the greatest pleasure our visit to Sedalia and especially you and Alyce. We don't have the words to express our love and gratitude to and for you for your tireless effort in our behalf, but we want you to know that you have a special place in our hearts always.

Please accept this small token of our love and gratitude it is something to remember us by. Take care till we see you again.

All Our Love

Donita Fowler, Lillian McDonald & La Emma White

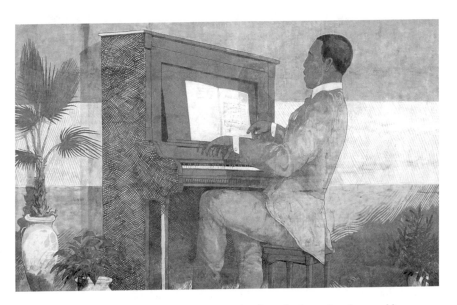

This mural painted by Stan Herd of Kansas depicts Scott Joplin at the piano and is displayed on the wall of a building located on Hio Avenue and Second Street in Sedalia. *Photo by Jeff Smith.*

The community center in Columbia is named in honor of J.W. "Blind Boone." *Courtesy of the Collection of Rose M. Nolen.*

J.W. Blind Boone Park in Warrensburg is the creation of a group of volunteers that set out a few years ago to renovate a once "black" park into a modern recreational space for residents and visitors. The park features a sculpture of the great musician by sculptor Ai Qiu Hopen.

SCOTT JOPLIN'S LIVING LEGACY

African American ragtime musician Reginald Robinson of Chicago was just a big city kid when he first heard Scott Joplin's tune "The Entertainer." He was out on the sidewalk waiting for the ice cream truck when he heard the melody emanating from the truck's sound system.

It wasn't until he was a teenager that the King of Classic Ragtime's music became a part of his regular routine. Teenage gangs had invaded the neighborhood where he was growing up, and as a result he dropped out of school. He used the time for something he had always wanted to do. He began to study music. His two brothers brought him two books

to study. One was a high school book, and one was a grammar school book. One of the books was on music theory, and one was on basic music. After studying for some time, Robinson, like Scott Joplin, taught himself to play.

Robinson explained that he made charts and learned about such things as ledger lines and the difference between a G clef and an F clef. Then he would listen to Scott Joplin's music and hear how an eighth note before a sixteenth note sounded in a bar. He could hear what the notes sounded like, so he learned what note to put before another to create syncopation. Then he read the book *They All Played Ragtime* by Rudi Blesh and Harriet Janis and found that the music was what he thought it was. This is how he learned to write down music, and then he applied it to his own music.

When he learned to write down his music, he began to create more and more music until eventually he had enough to make an album. At that time, he went back to school in an effort to get his GED, and it turned out that many members of the school's faculty were also musicians.

One day, he was sitting in the hallway waiting for school to start, and as usual he was writing music; a faculty member saw what he was doing and asked if he was a musician, and Robinson replied that he was and the two agreed to meet after school to talk. The faculty member introduced Robinson to his music teacher, and when she offered to teach him for free he accepted. With the faculty member's help, he met other musicians, and after hearing him play his music they became interested. Jon Weber, who was performing at the Four Seasons Hotel in Chicago, was impressed when he heard Robinson's music, and when he realized that it wasn't recorded he offered to pay for a demo. When he had his demo, one of his supporters introduced him to the president of Delmark Studios, who asked him to sign up, and the rest is history.

Reginald Robinson has performed at both the Scott Joplin Festival and the J.W. Blind Boone Ragtime and Early Jazz Festivals, and in 2004 he was presented with a MacArthur Award of $500,000 with no restrictions for his dedication and commitment to ragtime music. In addition to his performances, Robinson also researches talented ragtimers performers and attempts to rescue them from obscurity.

Robinson says that although he enjoys performing at festivals, by working in schools he realized that he was not reaching the young people he needs to influence in order to pass on the Scott Joplin legacy. As his way of addressing that issue, he is currently making a documentary that he can present to audiences on the subject of ragtime.

Mid-Missouri's Historic African American Places

Mid-Missouri is home to many African American treasures. When slavery ended in Missouri in 1865, as soon as the former slaves established their own communities they began to build churches and schools. Many of them are still in existence.

Boone County

The J.W. "Blind Boone" home is located at 10 North Fourth Street in Columbia. It was built in 1880. Boone and his wife, Eugenia, lived in the two-storied structure until his death in 1927.

Second Baptist Church at Fourth Street and Broadway in Columbia was completed in 1894. J.W. "Blind Boone" lent $3,000 toward the construction of this brick masonry structure, which is located in the same block as his home.

Second Christian Church, also known as Fifth Street Christian Church, is located at 401 North Fifth Street in Columbia and was formed in 1872. The structure that houses the congregation today was built in 1927.

The J.W. "Blind Boone" home is located across the street from Flat Branch Creek, after which he named his "Southern Rag Medley No. 2 Strains from Flat Branch." *Courtesy of the Collection of Rose M. Nolen.*

Second Baptist Church is located next door to the Boone home and is just one of the many institutions in Columbia that benefited from Boone's generosity. *Courtesy of the Collection of Rose M. Nolen.*

Second Christian Church is just one of three historic churches in Columbia. *Courtesy of the Collection of Rose M. Nolen.*

The St. Paul AME Church of Columbia was built in 1892. *Courtesy of the Collection of Rose M. Nolen.*

St. Paul AME Church, located at 501 Park Street in Columbia, was organized in 1867. The present brick masonry structure was built in 1892.

COLE COUNTY

The Lincoln University Hilltop Campus Historic District is located at 820 Chestnut Street in Jefferson City. First known as Lincoln Institute, it was organized and incorporated in 1866. The idea of a black school to serve discharged veterans, some having learned to read and write in the army, was conceived by two white officers, Lieutenants Foster and Adamson of the Sixty-second Colored Infantry, during the Civil War. Foster agreed to run the school if money could be raised to start it. Donations were solicited from the Sixty-eighth and the Sixty-second Colored infantries. With the contributions of the soldiers and some of the white officers and financial help from the Freedman's Bureau, the school was constructed.

The entrance to the Lincoln University Hilltop Campus Historic District is located on Chestnut Street in Jefferson City. *Courtesy of the Collection of Rose M. Nolen.*

Lincoln University was founded with donations furnished by the Sixty-eighth and the Sixty-second Colored Infantries, who served in the Civil War. Founder's Hall is located near the statues representing the infantrymen. *Courtesy of the Collection of Rose M. Nolen.*

Young Hall on the historic Lincoln University campus is located behind the statues of the infantrymen. *Courtesy of the Collection of Rose M. Nolen.*

COOPER COUNTY

St. Matthew's Chapel AME Church is located at 309 Spruce Street in Boonville. The structure is a one-story, brick, Gothic Revival–style structure with a three-story tower jutting from the façade. The church was founded in the 1880s, and the present structure was completed in 1892.

Sumner Public School is located at 321 Spruce Street in Boonville. It is a two-story brick building with a full basement. It is the second of three school buildings that served black students in the area. The first one was founded in 1866. When the first school burned down, this second one was constructed in 1915–16. This building was used until 1939. At that time, a new Sumner Public School was built in east Boonville.

St. Matthews Chapel AME Church is one of the oldest black institutions in Boonville. *Courtesy of the Collection of Rose M. Nolen.*

Boonville's second Sumner School served black students from 1915–16 through 1939. *Courtesy of the Collection of Rose M. Nolen.*

PETTIS COUNTY

C.C. Hubbard High School is located on the corner of Osage and Henry Streets in Sedalia. It is a two-story brick building. It began life as Lincoln School and was founded in 1867. It was enlarged from a two-room to a four-room facility in 1879. In 1906, Christopher Columbus Hubbard became principal of the school and introduced a four-year high school curriculum in 1916. A separate high school was built in 1926 and annexed to the Lincoln building. In 1942, the name of the school was changed in honor of its longtime principal, C.C Hubbard. In 2000, it was purchased by the Maco Development Company and now houses the Lincoln-Hubbard Apartments.

SALINE COUNTY

The Free Will Baptist Church of Pennytown is located eight miles southeast of Marshall, Missouri, off MO UU. Pennytown was one of several black towns founded in Missouri following the emancipation of

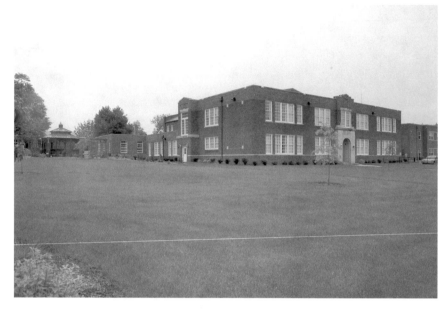

C.C. Hubbard School in Sedalia began life as Lincoln School in 1867. Today it is home to the Lincoln-Hubbard Apartments. *Courtesy of the Collection of Rose M. Nolen.*

Renovations of the Free Will Baptist Church of Pennytown were completed in 1886. It was placed on the National Register of Historic Places in 1988. *Courtesy of the Collection of Rose M. Nolen.*

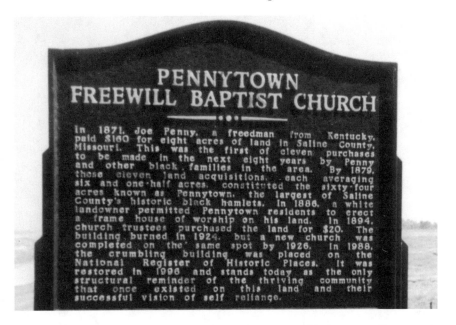

This marker, which stands beside the Free Will Baptist Church in Pennytown, tells a part of its story. *Courtesy of the Collection of Rose M. Nolen.*

slaves. The town was founded in 1870 by Joseph Penny, a free black man from Kentucky, on land he purchased in Saline County. At one time, it had as many as two hundred residents. The church was built with permission on a white landowner's property. Materials rescued from a dismantled former white church were used to construct the building. In 1894, a new landowner sold half an acre to the trustees of Free Will Baptist Church. The building was the center for activities held in the community until it caught fire in 1924. The church was rebuilt in 1925– 26. Pennytown remained a community until the first half of the twentieth century. Descendants of members of the former community still gather for an annual reunion at the church.

THE BIGGEST LITTLE BLACK COLLEGE
ON THE PRAIRIE

It was 2:00 a.m. on Sunday morning, April 26, 1925, when two local men returning home from a fishing trip spotted smoke pouring out of the small tower atop the George R. Smith College for Negros and sounded the alarm.

Before long, the blaze had illuminated the sky for miles around. Although the firefighters who responded immediately fought hard to control the conflagration, it soon became obvious that the fire had too much of head start; the fighters lost the battle. The school was doomed.

While rumors were rampant that at least one individual was stranded inside the building, that turned out not to be true. In the end, no lives were lost and no one was injured. The faculty of twelve and the students who were housed in the building were found to be safe. As a crowd quickly gathered to observe the fiery spectacle, African Americans who lived nearby came to the rescue of the stranded students and arranged housing and clothing where needed. An organization of black men called the Lion Tamers immediately assumed responsibility for the group and began to address their requirements.

Within a short time, the walls of the college collapsed, and gradually the grand building was totally destroyed—with but a few of its furnishings, including some bedding, salvaged. In assessing the amount of damage to

The conerstone of George R. Smith College was uncovered several years ago. It is presently at home at the Pettis County Historical Society in Sedalia. *Photo by Jeff Smith.*

the school, the president of the school, Dr. Robert Hayes, estimated that the loss to the building would total $100,000. He said that it was only insured for a meager $20,000.

In spite of the extensive damage to the institution, the stalwart souls in charge of the college were determined to move forward. Taking immediate steps to proceed, classes were held at two black churches within the community: Taylor Chapel ME and Freewill Baptist Church.

George R. Smith College was an institution beloved by all races in the Sedalia community. It had a stellar reputation, and its students and faculty were held in high regard. The history of the school dated back to 1888. A that time, Martha Smith and Sarah Smith Cotton, surviving daughters of Sedalia's founder General George Rapeen Smith, decided to fulfill a request by their father and gave twenty-four acres of rich

farmland to the Freedmen's Aid and Southern Education Society of the Methodist Church for the construction of a building for a school. The building was to cost at least $25,000 and was "to be devoted to the moral and intellectual culture of the colored people of the West."

The site selected for the school was a section of park-like prairie land in the northeastern suburb of Sedalia. The twenty-four-acre campus was planted with four hundred shade trees. The red brick building with stone trimmings was situated on a knoll. It was four stories tall, with a deep basement. It boasted a 120-foot frontage and was 40 feet deep. The ell measured 75 by 40 feet. The builder was William LaPorte.

The building's interior contained sixty-two rooms, including a chapel with a seating capacity of four hundred and male and female dormitories for seventy-five boarding students. There was a suite of rooms for the president and apartments for teachers. Included was a dining hall, a kitchen, storerooms, a cellar, a laundry, laboratories, an office, a library, a guest room, music rooms, a society hall and bath and toilet rooms. The facility was heated by steam and lit by gas and electricity The structure was built at a cost of $40,000 and, along with its elegantly landscaped campus, had a total value at that time of $60,000.

One measure of the success that the Smith sisters' venture was ultimately to earn was that news of the destruction of George R. Smith College was of such importance to the Sedalia community that it was covered by a second edition of the city's daily newspaper, the *Sedalia Democrat*. This was only the second time in that newspaper's recent history that such an event had occurred. The first was on the occasion when the Pettis County Courthouse burned down in 1920.

While many attempts were made to raise funds for the rebuilding of the school, including one plea by Sarah Smith Cotton herself, those efforts proved to be in vain. The school was never rebuilt. The Methodist Episcopal Society of Chicago, to whom Dr. Hayes appealed for help, was itself in financial straits, which would ultimately dictate the closing of several of the schools it sponsored, including George R. Smith College.

Still, in its brief thirty-one years of existence, its reputation for excellence was respected far and wide. The school educated thousands of

African American students, sending out future teachers, lawyers, doctors, ministers and pharmacists all across America.

When George R. Smith College opened its doors to students in 1894, it was the youngest of the Freedmen's Aid Society schools and one of the few black colleges north of the Mason-Dixon line. Its first term consisted of four months, during which it enrolled fifty-seven students. For its first full academic year, 1894–95, sixty students were enrolled. The first president of the college was Reverend P.A. Cool, DD, ex-president of Wiley University.

For the school term 1895–96, one hundred two students were enrolled. At that time, Sedalia was involved in a major campaign to have the capital of the state removed from Jefferson City to Sedalia. Although this effort failed, the school's annual catalogue was produced with the great expectation that such a removal would take place. Its "General Information" section included a note relating what advantages the college expected to gain when the change took place and inserted that information under the title "Capital-Elect."

In its annual catalogue for that school term, the school administrators discussed what the school was designed to do:

> *The object had in view in this Institution was to provide means for the thorough and systematical education of the colored youth in all those branches necessary to usefulness and happiness. The paramount purpose is to combine broad intellectual training and careful moral and physical training with comforts of a good home, at the least possible expense.*
>
> *The aim is to lead the youth to form and cultivate habits of accuracy, care, promptness, neatness, cleanliness, economy, to instill in their mind and heart the principles of manliness, womanliness, truthfulness, faithfulness, loyalty to principle, the dignity of honest toil of any kind, a love for learning and significance of life itself. Such lessons we believe to be of greater value to young people than any mere book knowledge. We therefore strive to give a sound, sensible and practical training, emphasizing the necessity of a Christian life, a cultured brain, a social refinement and a skilled hand.*

Of its religious culture, it boasted that the school was noted for its high moral tone and intense religious spirit. It went on to add that it combined a thorough intellectual training with practical Christian teaching. Socially, it intended to render young people polite and refined in their manners in all places of society. In recognizing the importance of physical culture, the school was quick to point out that its ample grounds provided space for baseball, football, croquet and tennis, as well as room for military drill. It also offered the opportunity for light work in and around the building.

Its admission policy required that all students agree to the willing performance of all duties prescribed by the school and to govern himself or herself according to the rules. Students were required to present satisfactory testimonials of good character. Those coming from other schools had to present certificates of honorable dismissal. The school stressed that it aimed to be particular in relation to the character of its students. "Young people of bad habits are not welcome here," the catalogue noted. "We are favored with students of excellent principles, and we wish to shield them from contaminating influences." While there were no age restrictions, it was recommended that no pupil under the age of fourteen be sent to the school.

In an effort to achieve the character of a Christian college family, the faculty and the students lived together on campus and shared the same tables when dining. Students who did not work or live with relatives were required to board on campus. Dormitory accommodations were rooms averaging twelve by fifteen feet and were to be shared by two students. They were heated by steam heat and were provided with a bedstead, springs, a mattress, a pillow, comforts, linen, a dresser, a mirror, a washstand bowl, a pitcher, a lamp and chairs. Students were responsible for maintaining their rooms, which the faculty inspected. Pupils were required to furnish their other personal necessities. Women were advised to bring rubber boots, raincoats, umbrellas and sturdy walking shoes along with shawls and cloaks.

The dress code stated that clothing should be neat and not extravagant. It was suggested that all students wear uniform suits of blue. Young women's suits were to be of navy blue flannel, blouse or sailor waist and plain skirts; the young men's suits were to consist of the regular military

uniform. It was noted that "this style and quality of clothing is in fact cheaper and neater than the ordinary styles worn."

Attending religious services in the chapel every morning, as well as morning and evening worship services every Sunday at the church of their parents' or guardians' choice, was a requirement. If the students did not belong to a specific church, then he or she was required to attend the Methodist Episcopal church. Students were also required to attend a college Bible class. One was held by the president each morning and one by the Epworth League in the afternoon. There was also a weekly prayer service on Wednesday afternoon. It was noted that all religious teaching was nonsectarian.

Obviously a no-nonsense approach was taken toward student discipline. While the college admitted that it welcomed as students "young men and women of high aspirations, noble purposes and wide-awake energy," it stated clearly that it had no place for "drones, idlers or incorrigibles" at the school:

> *The discipline of the school combines mildness and firmness, avoiding harshness and unwarrantable severity, yet inculcating strict order, prompt obedience, correct deportment and preserving industry. Hence, while obedience to rules is required, the government is largely one of brotherly kindness. We do not believe in a mechanical rigidity, but in a paternal and fraternal spirit. Each student will be furnished a copy of the rules and regulations of the College.*

Following is a list of such rules, from the twenty-second annual bulletin of George R. Smith College.

THINGS STUDENTS ARE NOT ALLOWED TO DO

Deface the school building and furniture.
To use tobacco and intoxicating drinks. Those found violating this will be punished severely.
To play cards and other games of chance.
To laugh aloud and make unnecessary noise in and around the building.

To leave town without the permission of the President.
To use obscene and profane language.
To visit circuses, races and theatres.
To be irreverent at religious services, to desecrate the Sabbath nor to make any other breach of good morals.
To carry firearms and other dangerous weapons.
To have interviews with the opposite sex on the campus or about the building, either during or after school hours, without permission.
To contract debts without the consent of parents or guardians.
To talk from the windows, to throw things from there or to sing in the halls.
To visit each other's rooms during study or quiet hours without permission.
To visit the different halls without permission from their own preceptress or preceptor and the one in charge of the hall visited.
To remain in the laundry during school hours.
To congregate in living rooms.
To go shopping or visiting off the campus unless accompanied by the preceptress or some authorized person.
To leave the ground without the permission of the one in charge.

Following is the college song:

George R., I love old George R.;
I love her halls and her campus green.
Boys there are strong and steady,
Girls the finest that I have seen;
Rah! Rah! Rah!
Sun there is always shining
Skies there are always blue;
George R, we love old George R.,
And we students to her will be true.
From the Twenty-Ninth Annual Bulletin
George R. Smith College

To put parents at ease in sending their children to a coeducational institution, the school advised parents that young ladies would be under

the immediate supervision of a thoroughly competent preceptress and that the ladies hall was entirely distinct from that of the young men. The administrators went on to advise that young ladies and gentlemen met only in the presence of their teachers in the recitation rooms, the dining hall and the chapel. The purpose, they noted, in the government of the school was to cultivate in the minds of the students the habit and develop the power of self-government.

The school year was eight months long and was divided into three terms of ten weeks each. The basic cost was $10.50 per school month. The college required that all bills be paid in advance by the first day of each school month.

COURSES OF STUDY

There were eight courses of study at George R. Smith College. They included classical, philosophical, scientific, normal, commercial, English, musical and industrial. Included were classes in agriculture, astronomy, biology, chemistry, economics, sociology, history, education, English, French, geology, Latin, mathematics, philosophy, psychology, logic, ethics, physics, political science and public speaking. Early records also noted classes in Greek, German and zoology.

The requirements for graduation and a degree of Bachelor of Arts were as follows: 126 semester hours—English, 12 hours (3 of which were to be in physiology and hygiene); foreign language, 12 hours; mathematics, 6 hours; history, 6 hours; physical education, 6 hours; economics and labor problems, 6 hours; American government, 3 hours; Bible, 3 hours; and psychology, 3 hours.

By the close of the second semester of their sophomore year, students had to select one subject for a major (twenty-four hours) and one subject for a minor (twelve hours).

A written examination was given in all classes, monthly. To pass in a study, the average of a student's standing in class recitations and written examinations had to be a least seventy-five points on a scale of one hundred. If a student failed, the class had to be repeated and

an examination passed satisfactorily before the student was allowed to graduate. Students who failed could be permitted by the faculty to retain their places in their classes.

Parents or guardians had to request reports in order to receive them. A demerit record was kept, also. Tardiness, unexcused absences and disorderly conduct were grounds for a demerit. The demerit system called for students to be subjected to private discipline before faculty and public reprimand before the whole school or they could be expelled. To appear on the honor roll, an achievement of 100 percent in deportment was required.

The college used the grading system of A, B, C, D and E. Completion of the college preparatory, the normal or the college course earned students a diploma. Completion of other courses earned a special certificate.

In order to complete the English course, students were required to complete all studies within the course as far as the sixth grade before beginning the college preparatory course. The normal course was designed for those who desired to go into the field of teaching. This course of study was designed to give teachers a thorough knowledge of those branches of study that are required in the best public schools and that examining boards expect teachers to understand. The course was designed for three years of study, and each student who completed the course was entitled to a diploma of graduation The college also provided a teacher's agency whereby the president of the college maintained correspondence with school boards who were in search of good teachers. The college preparatory course offered students a thorough preparation for the College of Liberal Arts. It also offered a complete academic education. The three college preparatory courses were the classical, philosophical and scientific, which required three years each and led to corresponding courses in the College of Liberal Arts.

Special departments within the college included a Commercial Department with classes in penmanship, stenography and typewriting; Commercial Geography; Commercial Spelling; Commercial Arithmetic; Business English; Salesmanship; and Commercial Law. The Gregg Shorthand and the Rational System of Typewriting were taught.

There was a Music Department that offered courses in voice, piano, violin, organ and theory of music, harmony appreciation, wind

This "Grand March" was published by M. Minniolia Jackson, who taught music at George R. Smith College. *Courtesy of the Collection of Rose M. Nolen.*

instruments and public school music. The college had six pianos, two Victor record instruments for demonstration and one pipe organ.

This department had five classifications of students. Regular students were candidates for diploma (these students were required to be high school graduates and sixteen years of age). This was a four-year course. Certificate students were those unable to pass required entrance requirements but who had proven musical ability. They were given certificates testifying to their completion of theoretical studies and their ability to perform. This classification required two years of study. There were also special students who were allowed to study the branch of their choice. Beginners were preparatory students. Finally, there was a class for those wishing to teach music in the public schools.

The college had several music organizations. There was a Handel Society, Choral Club for Men, the George R. Smith Orchestra and various music groups.

The Home Economics Department offered a four-year course in domestic science and domestic arts.

When the Printing Department was added, the first issue of the school's newspaper, the *Kinetoscope*, was published on May 1, 1897. Describing itself as "A Paper of College Life and Literature," the subscription rate for the paper in November 1898 was fifty cents per a ten-month year or five cents per copy. The purpose of the newspaper was outlined as follows:

> *The object of the Kinetoscope will be to diffuse light and knowledge among men—and women, too, who according to Moses' account of their origin are only a "side issue." So far as we can, we will do our share in elevating our common humanity and especially in "giving color" to the journalism of the day.*
>
> *It is our especial purpose to reflect in some measure the light and life of George R. Smith College. We shall give our humble opinions on matters and things; we shall report the College news, we shall set forth the advantages of this institution, its great mission, its wonderful growth, its present prosperity and the flattering prospect of its future usefulness.*

Some years later, the name of the newspaper was changed to the *Smithsonian*, with the first issue bearing this title, appearing on December 18, 1901. The price of the issue was two cents per copy, and by 1902 the price had been reduced to one cent per copy.

For some time, the school also published a journal entitled the *Weekly Conservator*, which dealt with racial issues, promoted the advancement of blacks and new methods of education and ultimately was said to have become one of the best black publications in Missouri.

The Saturday, August 15, 1903 edition published a copy of a letter from President Franklin Roosevelt to Governor Durbin of Indiana in which the president praised the governor for taking a stand against lynching, and the paper also reported detailed information about the nineteenth annual session of the Grand Lodge of Missouri, which met in Mexico, Missouri.

Agricultural students at George R. Smith College helped work and maintain the farm that provided food for the college table. The school

also taught a course in military science and tactics. All male students were required to attend military drill. Although they were not required to purchase uniforms, the college encouraged them to do so because they were allowed to wear uniforms every day. The state provided all of the other equipment needed for the class. A nurses training course provided a three-year preparatory program for those who desired to go into professional nursing.

Two courses in Bible and three courses in religious education were offered in the field of religion. The course in English Bible dealt with contents, structure, geography, growth, history and institutions of the Bible. It also included a chronological outline, a study of the life of Christ and the four gospels and the history of the Christian church.

The second Bible course was designed for local preachers interested in furthering their education. Those engaged in the ministry were also allowed to pursue the conference course of study outlined in the *Book of Discipline*. Full credit for work done at George R. Smith was accepted at Methodist Episcopal seminaries.

In order to graduate from either the college preparatory course or the normal course students had to participate in one year of Bible study.

Life at George R. Smith College was not without its fun side. There were a number of clubs and organizations available for student participation. Membership in the Athletic Association was two dollars, and all students were members. The campus had a baseball diamond, a football field, tennis and croquet courts and a running track. The school had a football team, basketball and baseball teams for the men and a women's basketball team. Young women could play tennis and croquet as well. Following is the college yell:

> *Rickty! Rickety!*
> *Zis! Boom! Bip!*
> *Rah! Rah! Rah! Rah!*
> *George R. Smith;*
> *Hip! Hip Hey!*
> *What shall we say,*

Se-da-li-a;
Se-da-li-a;
S-E-D-A-L-I-A.
Sedalia
Mi-ss-ou-ri
Mi-ss-ou-ri;
M-I-S-S-O-U-R-I
Missouri.

The college had both a YMCA and a YWCA, with a 100 percent membership by both groups. Each of the two met weekly for programs of a literary and recreational nature. There was a Smithsonian Literary Society that involved itself with drills in parliamentary usages, original literary work, public speaking and debate. The college also had a chapter of the I. Garland Penn Debating Club.

The Epworth League was an organization in which the students took part in discussion of the religious program carried out on Sunday evenings. The league also had a Mercy and Help Board, which helped among the poor and needy of the Sedalia community.

Friends of Africa was a group designed to interest students in foreign missions, primarily in Africa. This organization held prize contests in hymns, essays and orations each year, with the Stewart Missionary Foundation awarding the prizes. Winners of the local contests were then entitled to participate in the grand contest, which was held during the commencement exercises of Gammon Theological Seminary. The group supported a scholarship in West Africa College.

Members of the faculty belonged to the Phi Beta Sigma Fraternity, which was organized at Howard University in Washington, D.C., in 1914. The Theta Chapter was formed at George R. Smith College in January 1920.

George R. Smith College had a celebration that was uniquely its own. It was called Frock and Apron Day. The origin of the celebration dated back to the early years of the school's history, when the Central Missouri Conference of the Methodist Episcopal Church convened in the northwestern part of the state; upon hearing about the school, the

conference administrators decided to pay it a visit. Upon adjournment of the conference, the ministers arrived in Sedalia on the same train accompanied by their wives. The occasion stirred a great deal of excitement on the campus, and the students were greatly impressed with the various styles, colors and fits of the minister's coats. At the sight of their wives in white aprons spreading out their dinner under a large shade tree on campus, the students decided to mark the event annually as Frock and Apron Day. After that, the celebration was held on the last Friday of each February.

THE HORSE MAN OF MID-MISSOURI

A name well remembered in equestrian circles throughout the nation is that of Tom Bass. The inventor of the "Bass bit," long considered standard equipment in horse stables everywhere, was born in 1859 in Boone County, Missouri. His mother was a teenage slave girl on the farm of Eli Bass, one of the wealthiest landowners and largest slaveholders in the mid-Missouri region nicknamed "Little Dixie." Tom's father was Eli Bass's son, William.

His grandparents, Presley and Eliza Gray, along with their fourteen children, brought up Tom. Presley Gray was Eli Bass's coachman. And unlike many slaves, Presley and Eliza had been permitted by the Bass family to marry. The Grays are remembered by Boone Countians today because Presley Gray was one of the founders of Log Providence Church, which continues as a house of worship for black parishioners, most of whom reside in Columbia. Gray and his sons were members of a group who cleared the land and constructed the original log structure.

Bass came from a family of storytellers who passed down family stories from generation to generation. Tom is said to have begun to ride the Basses' champion saddle horse, Helen Macgregor, by the time he was four years old. Young Tom had developed an affection for the big horse, and he took advantage of every opportunity to be in the horse's company.

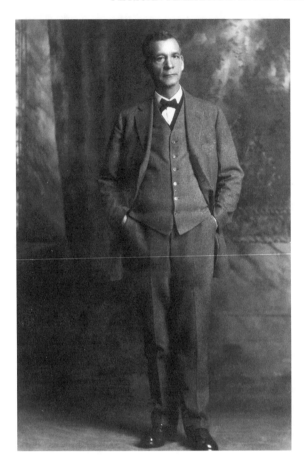

Tom Bass, who became one of the best horse trainers in the country, rode his first horse when he was four years old. He rode Miss Rex at the Chicago World's Fair Columbian Exposition's horse show, and she was chosen First World Champion saddle horse. *Courtesy of the State Historical Society of Missouri Columbia.*

The two were so close that many claimed that they saw Tom talking to the horse and the horse bending her head to listen. Eli Bass died shortly after the Civil War. With emancipation, many slaves left the farm, but the Grays were among those who chose to stay as sharecroppers. Like other Southern sympathizers, the family was forced to surrender a portion of their wealth to the federal government as payment for war crimes.

It was in 1866 that Tom was allowed to attend his first horse show. William Bass was going to show Helen MacGregor at the Boone County Fair. Tom was allowed to go along to take care of the horse's stall. Tom used the time to learn everything he could about horse shows. By listening to the trainers talk, he was able to pick up nearly everything he needed to know about the horse business. He learned the language of

the horse people and how the competitions were set up. Although Helen MacGregor came in second place, Tom had been awarded a wonderful learning experience. Unfortunately, a few weeks after the horse show, Tom experienced his first great heartbreak. Helen MacGregor was found dead in her stall.

The boy was grief-stricken for days. His grandfather, hoping to find a way to console Tom, gave him the responsibility of exercising the family mule, Mr. Potts. The animal, known for his stubbornness, would provide Tom with a big challenge, or so Presley Gray thought. After a few hard-fought skirmishes, it was no time at all before Tom was able to saddle the mule and get him moving. Later, when some young white boys who were friends of the Bass family were in the corral taunting the horses, they saw Tom and began to harass him and threatened to teach him to ride. Tom walked off, declaring that he needed to get dressed for his lesson. His grandparents heard the exchange from inside their cabin. His grandmother gathered his grandfather's Sunday clothes for Tom to wear, and the boy asked Presley to put a saddle on Mr. Potts because he was determined to ride his own family's mule.

When Tom returned to the corral dressed in his grandfather's clothes and hat, riding the mule, the boys ridiculed him and laughed even louder than before. When Tom and Mr. Potts had finished circling the corral once, the mule pulled himself together and started to behave like a horse, following Tom's directions; the laughing ceased as the mule pranced and his hoofs hit the ground separately in a four-beat gait. The crowd around the corral had grown and now included William Bass, Presley, Eliza Gray and other sharecroppers. Soon, under Tom's direction, the mule's rack became a canter, and the crowd went wild. The boy then led the mule into the middle of the corral, where Mr. Potts lowered himself to bow to the audience. With Tom pulling the reins, Mr. Potts stood up again, moved backward and suddenly began to canter backward. At that point, Tom Bass had taken his first step into horsemanship history.

Presley and Eliza bought a house in Columbia in 1870 and moved from the Bass Farm. The William Bass family had moved there a few years earlier. Presley Gray was a proud man who had secretly taught himself

to read and write. He accomplished this by listening quietly whenever business of any kind was being discussed and by paying close attention to every document he came across. He was concerned about his grandson's education. Tom dropped out of school after the third grade. Tom's interest in the horse business seemed to outweigh everything else in his life, and he disappointed his grandfather due to his lack of interest in acquiring any further education. Presley understood the importance of being able to read important papers and count money. Nevertheless, he was unable to convince his grandson. Tom helped his grandparents move into town, but he remained behind on William's farm, where he trained horses and accompanied William Bass to horse shows throughout the area.

By 1878, Mexico, Missouri, was hailed as "horse territory." A few years earlier, at the Boone County Fair, Tom had met Joseph Potts and Cyrus Clark. The men were partners in the Mexico Horse Sales Company. This was a large and successful business in this part of the state. Joseph Potts was quite impressed with Tom's remarkable talents, and so he had given the young man a note to present to a potential employer, in case he ever needed to find work. Tom held onto the note for a long time before deciding to leave the Bass Farm. Once he finally made up his mind to leave, he hiked and caught rides to make the trip a few miles north of Columbia.

He had been told that the owner of the Ringo Hotel, where many horse people stayed, might be a good person to contact. So as luck would have it, the day he met the owner, Louis Hord, and gave him Potts's note to read; he was offered a job as a carriage driver for the hotel. It didn't take Tom long to work his way into being given the position of head of the stables. Tom, of course, excelled at training horses, and his reputation got around; it wasn't long before he was kept busy as a horse trainer.

After watching Tom work and becoming convinced that Tom had a special way with horses, Potts expressed to his partner the desire to hire young Tom to buy and train horses for the company's annual sale. Unfortunately, Cyrus Clark was dead set against his partner's plan. He found it unthinkable that Potts would consider hiring a black man for such a job. He thought that while it was fine for black people to perform common labor for the company, having Tom scouting horse country

in search of good horses to buy, carrying the money in his pocket, just wasn't the kind of thing black people were suited to do. And while Tom had trained horses for sale, he had never been a part of a crew to handle the entire responsibility. Clearly, Clark felt that the customers would not want to deal with a man of color when such big decisions had to be made. The two men struck up a deal whereby Potts would use his own (not the company's) money to pay for the horses Tom bought for the sale. With the deal made, Tom was given the job. The sale was drawing near, and Tom offered that he knew of some good horses that could be found in Boone County. Potts, ignoring his naysaying partner, sent Tom Bass off with a roll of bills in his pocket.

As sale day neared, Tom returned with his finds. As the story goes, the six horses that were following behind him were the grungiest animals that had ever trod hooves on the property of the Mexico Horse Sales Company. The horses were so hideous-looking that even Joseph Potts's spirits failed when he saw them. On the other hand, Bass seemed to be elated with his finds and fell to taking every opportunity to work with them—so much so that he wasn't doing his share of the many other tasks that had to be done in advance of the sale.

But when time came to bring the horses into the auction ring to list their special qualities in the sales catalogue, Tom scored again as three silky-smooth beautiful horses followed his lead. Behind the scenes, Tom had groomed his horses to the extent that they literally gleamed with polish and grace. That was the last time that Cyrus Clark expressed any doubt that Tom Bass was not Missouri's finest horse trainer.

Since so many years had passed since Tom had said goodbye to Helen MacGregor, he probably thought he would never see another horse as beautiful as Helen. But he would have been wrong in that thinking. When the horse show of 1879 was over, and he and the other members of his crew went out in search of horses for the next sale, he passed a farm and spotted a beautiful black mare standing alone in a pasture. Tom asked the farmer for the price of the mare; the farmer complained, said that the horse had a terrible personality and implied that she was the meanest mare in Missouri. Tom purchased the mare and took her back to the

company. While everyone agreed that she was a beauty, she had such a behavioral problem that the partners decided that she would require too much money to train and sent her off to pasture to be a broodmare.

Although Tom refused to go to school, he did go to church and as a result learned to read the hymnal. There was a method to his madness, to be sure. He had observed that girls would share their hymnals with the boy next to her if he could read. A young woman by the name of Mimi Johnson seemed to like sharing her hymnal with handsome young Tom. And, of course, one thing led to another, and Tom began to take her for buggy rides. It wasn't long before Mimi got pregnant. She gave births to twin boys, Ray and Ralph. The two lovers were never married nor lived together as a family. There is no information on why they went their separate ways.

When the partners decided that they needed a horse with championship potential, Tom wasted no time in putting in a plug for the black mare. The partners were not impressed with his suggestion, but of course they did not realize that Tom had been secretly training the horse. He finally persuaded them to come out on the following morning for a look-see, and the mare performed beautifully, as Tom knew that she would. The partners could not have been more pleased with her performance. They had their champion and named her Blazing Black, and she would be entered the following month in the Mexico Horse Show. The only question that remained was who would ride her. Both men knew that Tom had the skill to ride the mare, but Clark reminded Potts that black men did not ride in horse shows. It would have been more accurate to say that, so far, no black man had ridden in a horse show, because Potts went on to make it clear that Tom Bass would be riding Blazing Black at the Mexico Horse Show.

The moment Tom had waited for all of his life was now at hand. History was in the making.

Tom Bass riding Blazing Black won second place in his first horse show. From this point on, Tom's life would be radically different. Following his first win, he continued the season by riding all of the championship horses in the company's inventory.

It turned out that training and showing saddle horses were not the only contributions Bass would make to horse history. To Joseph Potts's surprise,

Tom shared with him the new bit that he had designed to protect horses' mouths. Potts was amazed and tried his best to get his friend to patent his invention, but Tom rebelled at the idea of having to deal with the paperwork involved in the patenting process; so the "Bass bit" was never registered at the patent office. Instead, Tom chose to sell his bits for what they cost him to make. In time, the "Bass bit" would be used everywhere saddle horses were bred.

In the early 1880s, Bass acquired both a new wife and a new business. He met Angie Jewell when she moved to Mexico with her younger sister to teach at the black school. The young woman caught the handsome bachelor's eye, and after a lengthy courtship the two were married. The following year, Potts and Clark sold their business. Tom didn't relish the idea of finding another employer and decided to go into business for himself. With the help of Joseph Potts, Tom was able to negotiate a loan to buy some land north of Mexico. He sold a one-eyed colt that he had purchased and trained for the money to build his house and barn. It was during the course of this transaction that his wife discovered that her husband was unable to count money. His wife found a mathematics book she had used when teaching and promised Tom that he would be able to count money before long.

After several years, Tom found a horse that he was confident he could train into a champion. He named his new gelding Columbus. While the two were getting acquainted, Tom received word that his grandmother had passed away. After her funeral, the grief-stricken horse trainer turned to the forty horses in his barn for solace. By keeping himself busy tending their needs, he was able to bear his grief.

After training Columbus for two years, Bass decided to enter him into the St. Louis Horse Show. He was the first black man to enter that contest. Because this was to be a "high school event," Tom had concentrated on training Columbus in the fancy footwork that he would have to perform in this show. The training paid off, and Tom and Columbus won the event. This was only the beginning for Tom and Columbus; they went on to win many other trophies, and when Tom taught the big horse to canter backward, the horse became the first horse to perform that exercise in competition.

In 1892, Tom Bass was invited to move to Kansas City to open a livery stable. Tom and his wife agreed to move. While there, Tom also became involved with the Kansas City Fire Department and its use of draft horses to pull fire pumpers. Teams of well-trained draft horses participated in contests at international shows. Kansas City was anxious to purchase expensive German draft horses so it could enter these popular competitions. Tom put together a fundraising horse show to help the city accomplish its goal. Tom performed on Miss Rex and Columbus at the show. The event was so popular that it led to other shows and ultimately evolved into the American Royal Livestock and Horse Show, which is still an annual event in Kansas City. While in the city, Tom seized upon the opportunity to organize the Tom Bass Riding Club for youngsters. The Tom Bass Riding Club is still in existence.

Shortly after moving, Tom received another invitation. This second invitation came from the Columbian Exposition, the Chicago World's Fair inviting Tom to perform at the exposition's horse show, where the champion of the world would be chosen. Tom accepted the invitation for the event being held in 1893. He decided that the horse he would take was Miss Rex. This was not a horse from his own stable, but rather one that he had persuaded his friend Joseph Potts to purchase. Miss Rex was sired by a champion named Rex Denmark. Potts agreed to buy the horse if Tom Bass would take care of her training.

During her turn in the ring, Miss Rex performed flawlessly, thrilling the crowd as she moved through her five gaits. She ended her performance amid thunderous applause. Making saddle horse history, Miss Rex was selected first world champion of the Columbian Exposition. The news of the duo's victory made world headlines, and they had hundreds of visitors, including President Grover Cleveland, who became one of Bass's many friends. As Miss Rex's incredible rise to fame swirled around the Bass stables, an offer to buy the horse for $6,000 came from a man who had traveled from England and represented Queen Victoria. The horse's owner at that time was a rich railroad owner who informed the man that Miss Rex was not for sale at any price. Finally, the queen's representative requested that Tom Bass and Miss Rex come to England and perform at Queen Victoria's Diamond Jubilee in 1897. Much to

his wife's disappointment, after dallying over the request for some time, he turned down the queen's representative. It seemed that Tom was uncomfortable about riding in boats.

The late 1890s became memorable in the life of Tom Bass for three reasons. First of all, his beloved grandfather Presley Gray passed away in 1896. The man who had treated him like a father was a giant in the eyes of his grandson. When Presley became too feeble to make his daily visits to his wife's grave, Tom provided money for a carriage service; when he couldn't attend Tom's shows, Tom's wife sent the older man newspaper clippings. In death as in life, Tom saw that his grandfather was laid out in a white silk shirt in a walnut coffin.

The second reason was one that would bring about an important change in Tom's daily life. Following his grandfather's funeral, Angie announced that she and Tom were about to become parents. Tom was delighted because he would have someone whom he could teach everything he knew about horses.

As for the third reason, in 1897 Tom was invited to appear at Madison Square Garden and at all the major horse shows.

The invitations, especially the one from Madison Square Garden, created a problem for Tom. By this time, he and his wife had moved from Kansas City back to Mexico, and Tom didn't like to be away from home more than one day. He definitely was determined to be present at the birth of his child. However, his wife knew how important this event was and that her husband would be the first black man to be a part of this major show, and so she tried to talk him into it. Angie got her way, and Tom and Miss Rex departed for New York. In addition to the ribbons they won, they were cheered on by many fans, including members of the Vanderbilt family (Alfred Vanderbilt had seen Tom perform at the Kansas City Show), as well as another friend, Theodore Roosevelt. Upon his return home, he was surprised and astonished when Miss Rex's owner presented the champion horse to him as a gift.

Inman Bass was born to Tom and Angie Bass on August 10, 1897. Along with his parents, the horse show world applauded his appearance. He was the heir to his father's throne as horse trainer extraordinaire.

In his new role as a father, Tom, who never managed money well, realized that he needed to begin thinking about the family's future finances. The first action he took to was to contact Buffalo Bill Cody, owner of the famous Wild West Show, to see if he was ready to honor a promise he had made several years ago. At the time, Cody wanted to purchase Columbus but didn't have the money, so he promised to come back for the horse when his finances improved. Cody responded immediately. He sent the money for the horse, and Columbus was sent to Cody. The agreement was that Tom could continue to show Columbus when he chose to.

Tom made that choice in 1901 when he performed with Columbus at the Mexico Horse Show. It was a fateful choice. When they were closing their presentation, Columbus reared up on his hind legs and then fell backward onto Tom. As hundreds watched, an unconscious Tom Bass was carried from the scene. Doctors found had Tom suffered a damaged pelvis and concluded that he would never ride again. Although it took Tom a year to recover, the pain stayed with him. He went back to the saddle again, but now when he pulled the reins, he realized that he had lost some of the grip in one of his hands. To Tom's great sorrow, Columbus ultimately perished in a fire in Georgia.

Belle Beach was the last horse Tom Bass would own. This was a horse whose birth he had encouraged. Tom admired the famous Missouri champion stallion Forest King and thought that a horse produced by him and Belle Morris, a horse owned by his old boss Cyrus Clark, would be another champion. Even though horse owners throughout the world sought Tom Bass's advice, Clark was a clever businessman and refused to pay the high stud fee the stallion's owner charged. Eventually, he persuaded Tom into a deal that angered all of Tom's friends. Tom would pay the stud fee, but Clark would own the foal, in which case Tom would come out of the agreement empty-handed. Nevertheless, Tom accepted the arrangement, and Belle Beach was the result of the match.

Clark put the young filly up for sale for $800. When there were no offers after a year, Clark gave the young horse to his son. It was obvious to Tom when he visited that Charles Clark could not handle the horse, so he offered to help. This went on for about three years before Cyrus Clark announced that he had sold the horse. As it happened, Tom Bass knew

the man who made the purchase. In fact, Tom had met the officer from Fort Leavenworth during his Kansas City years. He knew that the officer's wife had a passion for horses. She delighted to show off to her friends the beautiful horses that pulled her buggy. And she insisted on purchasing a new one almost every year. Tom had told the officer about the availability of Clark's horse and remained quiet throughout the transaction. It didn't take a year for the man's wife to tire of Belle Beach. He was back at Tom's doorstep within a few months. The pretty mare had not worked out. Belle Beach did not take kindly when any animal tried to pass her on the street and would take off like a rocket, forcing pedestrians to run out of her path and ramming into anything that stood in her way. At the fort where the officer and his wife lived, no horse was to go faster than a walk so that they would not frighten pedestrians. The officer asked Tom if he would take the feisty mare off his hands. The moment Tom had in mind had come at last. Belle Beach was at home in his stables where she belonged. To still her nervousness during horse shows, Tom ordered the band to play waltz numbers during their performances. Tom and Belle Beach were dancing partners for twenty years.

In 1927, Tom Bass suffered another major tragedy in his life with the death of his son Inman. Inman was plagued by alcoholism, a condition that he carried with him for most of the thirty years of his life. Like other parents, Tom blamed himself for his son's miserable journey to an early grave. As always, Tom turned to his horses for consolation and slowly regained his equilibrium.

Doctors had warned Tom that he had a weak heart and should avoid any strenuous activities. In 1929, he began seriously to think of retirement. In agreement with Angie, he decided to only train two horses at a time. When it appeared that his condition was fairly stable, he decided to perform at the St. Louis Horse Show, riding a mare that he had trained. In the middle of the performance, he experienced another heart attack and slumped over the horse. Tom recovered, but on the next attempt he made to ride a horse, he found himself too weak to mount. Horse show days for Tom Bass were over. A final blow fell when he found Belle Beach dead in her stall.

It would be easy enough to believe that Tom Bass's skin color—which came to him as result of his mixed parentage—his great talent, the admiration of presidents and queens and great people of the world, the praise, the awards, the trophies and the recognition would have prevented this emancipated slave from experiencing the kind of racial slights and indignities suffered by millions of others of his race; however, that would not only be unfair, but it would also be untrue. Eleven years after these Missourians had been freed from slavery, the Supreme Court of the United States of America decided in the case of *Plessy v. Ferguson*, a Florida transportation case, that "separate but equal" would be the law of the land. That decision reinforced segregation, helped establish Jim Crow laws and ensured further division of the races. That law was in effect for all of the days of Tom's life. Like blacks all over the country, he was often taunted, ridiculed and made to be the butt of racist jokes. When he traveled to his horse shows, he was not served in white restaurants or cafés. He had to cook his own food and eat in the barns. He slept in the stalls with his horses, unable to use public accommodations. Once, in Des Moines, Iowa, he was banned from participating in a horse show. Even the complaints of the white owners from Missouri were unable to gain his admission. These men earned Tom's gratitude by showing his horses themselves and giving him the collected awards.

People throughout the world honored him in life, but even death could not erase the abuse that racism heaped on Tom Bass. When he passed away on November 20, 1934, he was buried beside his son at the segregated Elmwood Cemetery in Mexico, Missouri. His wife Angie was laid to rest in 1941. Tom's son by Mimi Johnson, Ray, also died at an early age. Ray's twin brother Ralph was in his eighties when he passed away, suffocating in a fire in his home in 1962.

History remembers Tom Bass well.

A PLACE WHERE
MEMORIES MEET

If one opened the door today at the historic brick building on North Osage Avenue and Henry Street in Sedalia, one would be entering the lobby of the Lincoln-Hubbard Apartments. The story of how this handsome structure made the transition from a school for African American children to affordable living space for senior citizens is a tale about preservation of a building and a tradition of community service.

In the early years of the twentieth century, Sedalia's African American community could easily have claimed to have two of the finest educational institutions in mid-Missouri. For elementary and secondary classes, a black student would have attended Lincoln School. For higher education, he or she could have enrolled in George R. Smith College for Negros. Both institutions were top-flight schools known throughout Missouri for their excellence.

A year after its founding, a building to house Lincoln School was erected in 1868 on the northwest corner of Cooper Street and Moniteau Avenue. During that period, like African Americans throughout the nation, Sedalia's minority students had a thirst for learning. So, in 1879 the building was moved to Henry Street and Osage Avenue, and two more rooms were added to the structure, increasing its seating capacity to 260. At the same time, two years of high school were added to the eight

grades of the elementary curricula. The school's population continued to experience steady growth, and by 1895, 480 pupils were in attendance. A second story was built, and the building was expanded to include eight classrooms; Lincoln school was on its way to becoming a model institution of learning. Following is the college song:

> *Hail, all hail, our Alma Mater*
> *Our dear white and blue*
> *May thy precepts stand forever*
> *Noble firm and true.*
> *Hail, all hail, to thee dear Hubbard*
> *Loud our voices swell.*
> *To our noble Alma Mater;*
> *That we love so well.*
> *Many hails to thee dear Hubbard,*
> *For thy guiding light.*
> *May your diligent sons and daughters,*
> *Shine forth through the night,*
> *By the many years you'll tower,*
> *Proud and great and tall,*
> *As the mighty inspiration,*
> *That you give to all.*

The year 1906 was a very important in the history of Lincoln School. That was the year that Christopher Columbus Hubbard, a native of Glasgow, became principal of the school. Hubbard, who held a degree from Lincoln Institute (now Lincoln University) in Jefferson City, was known throughout the state as an astute educator. From the moment Hubbard took charge of the school, it began to flourish. His first accomplishment was to expand the high school term from two years to four. Consequently, the first high school class graduated from Lincoln School in 1917. It was a class of nine: two young men and seven young ladies.

After the arrival of C.C. Hubbard, Franklin Elementary School, which occupied the building formerly used by Lincoln school, was abandoned as

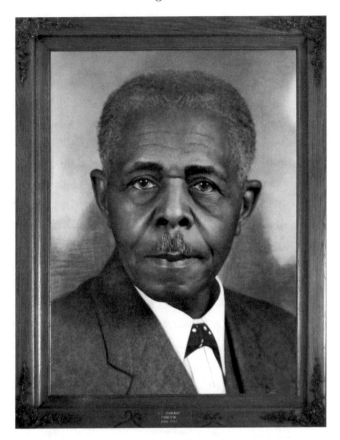

This photo of Christopher Columbus Hubbard hung in Hubbard School for many years. *Courtesy of the Collection of Lincoln-Hubbard School.*

a school for white students and reclaimed for African American students. Franklin served children from first through fifth grades. These students then completed elementary grades at Lincoln School. C.C. Hubbard's wife, Princess, served as principal of Franklin, which operated for twenty years, from 1907 to 1927.

In 1925, a commercial department was added to the high school curriculum. A high school building was added to Lincoln School in 1926. The new addition housed twenty-one classrooms, an auditorium-gymnasium, a shop for industrial arts, a home economics department, an office and a library. The class of 1929 was the first class to graduate using the new building.

Under Hubbard's leadership, the school, which had been established as an unclassified institution with thirty pupils, continued to gain ground.

The year 1927 saw the publication of the first school yearbook, the *Lincolnian*. The members of that year's graduating class eagerly expressed their gratitude to their principal in that publication by stating: "Through his rare humor and wit, he takes the dryness out of what would otherwise be ordinary school life."

By 1940, Lincoln High School had outgrown its local status and had begun to serve out-of-town students. Students were bused to the school from Marshall, Warrensburg, Versailles, Knobnoster, Tipton, Holden and a host of other towns within the area. The accomplishments and contributions of C.C. Hubbard to Lincoln school earned him the widespread praise of not only his students and their parents, but of the community as a whole as well. In 1943, the Sedalia Board of Education renamed the high school in his honor, and the school became the C.C. Hubbard High School. Attendant to this honor, the twenty-five acres of land donated by Sarah Smith Cotton (daughter of Sedalia's founder, George R. Smith) to be used as a park for African Americans, known as Dunbar, was renamed Hubbard Park.

As May 1947 drew rapidly toward its closing day, that year's senior class was busily preparing for its commencement exercises when word came on the morning of May 23 that Professor C.C. Hubbard had passed away. The legacy he left behind lingers on.

The stamp C.C. Hubbard printed on the face of the school was not easy to eradicate. The first man to attempt to follow in his larger-than-life footsteps was J.B. Hylick. He was accompanied by his wife, Serena, who taught English. Professor Hylick's authoritarian style of leadership was not an easy fit for students and teachers, who were accustomed to Professor Hubbard's firm but gentle hand. The relationship between Hylick, the faculty and students was at best on shaky ground. The tremor erupted in the spring of 1953 when Hylick suspended fifth-grade teacher Neppie Gearhardt and mathematics teacher Leo Fisher for insubordination to the principal, School Superintendent Heber Hunt and the board of education.

As a result of this incident, about 150 students stayed out of classes and paraded through downtown Sedalia in protest of the teacher's suspension. On Tuesday of the following week, the students and parents

sought the teacher's restoration and Hylick's removal as principal. The school board, following a hearing during which both sides of the confrontation were aired, removed the suspension of the teachers and discharged them. They tabled the petition for Hylick's removal.

A week later, the school board convened a special meeting, at which time J.B. Hylick presented his resignation in person. The board took no action on the resignation but rather ordered the students, under threat of disciplinary action, to return to school. At the board's regular meeting on April 9, 1953, the members accepted both Hylick's and his wife's resignations, to be effective at the end of the school term. The Hylicks were said to have accepted positions in the Chicago school system.

Three other men were to follow J.B. Hylick as principals of C.C. Hubbard High School. They were Beverly Foster (1953–56), C.H. Gooch (1956–63) and Harry E. Browder (1963–67). Mrs. Dorothy Kitchen, a teacher, was appointed principal of Lincoln Elementary School in 1957 and served in that capacity until 1973.

In 1985, Mrs. Dorothy Kitchen paid this tribute to C.C. Hubbard at a Black History Month observance at the Sedalia Public Library. It is reprinted here with permission:

First, just a word about black history. Black history is important or I could say not only black history, but history is important because people need a sense of history in order to make history. History can be dismal, dark and dreary—filled with disgust and discouragement. History can be hopeful and exciting—it can be many things, for it is a recording of events that belong to the past. History is knowledge—it is power. It orders and organizes our world. Sometimes we are too busy and concerned with the future to bother with the past. But I hope that we as individuals will not fail to teach our children that black history is important—just as the history of all other races is important.

We must teach our children that history is important because without a historical sensibility an oppressed people cannot respect themselves. Without a sense of the past and a sense of expectancy based on the future it is impossible for oppressed people to free themselves of tyranny here and now. If we had no historical record, we would be tempted to

believe the factorial lie of oppression. The factual lies of the present tell us that black people won't work and prefer welfare to honest labor, but the history of black people tells that no one in this country has done more work than black people and that no one in this country is owed more for the work they did from sun-up to sun-down without pay. So it is up to us to teach our children not to be ashamed when black history is mentioned in their classes, but to be proud of their heritage.

Now to tell you a bit about one we loved so well. One we admired and respected. One whose picture is gracing the halls of this library today. This same library that he encouraged boys and girls sixty years ago to use. This same library that he solicited discarded books from, to place on the shelves in the Lincoln Hubbard Library. Many of the books that we were first introduced to had card pockets stamped "Sedalia Public Library."

Professor C.C. Hubbard was a man of dignity and intelligence. He labored long and hard for better educational opportunities for the black children of Sedalia. He was devoted to helping others. He was a great educator and humanitarian. I hope you'll always be proud to teach your children about this great man—C.C. Hubbard.

Now the story of the life and work of Professor C.C. Hubbard cannot be told in words. His history is one of deeds. The school that once carried his name is a monument to his indomitable character, his unswerving faith in the power of the promises of God and his determined will to realize the dream of enlarging a little four-room structure that was known as Lincoln school. At the time of the closing of this structure, there were two buildings that remained standing, but in a very dilapidated condition. These two buildings consisted of 21 classrooms, a gymnasium-auditorium, a cafeteria, a shop of industrial arts, a home economics department, a library that was well equipped with new books. Books that were not handed down from other schools and the public library. Books that pertained to the life and works of great Negroes were popular in the school library when they could not be found anyplace else in Sedalia.

Professor Hubbard came to our community in 1906, and served as principal of this institution for black children until his death in

1947. Under his dynamic leadership the Lincoln Hubbard High School soon became accredited and accepted by the north Central Association of Secondary Schools and Colleges. This was really an honor for a school the size of Lincoln-Hubbard to be recognized and especially a black school.

Just the other day, I read where the review team from the North Central Association of Secondary Schools and Colleges was here to study Smith-Cotton which is our local public high school. I'm sure they passed with flying colors. But in the early days to be reviewed by such a team was quite an honor. Not only were we accredited, but a few years later Professor Hubbard, had made such an impression on the association that he was invited to serve on the board of the North Central Association.

He also served for 17 years on the Board of Curators for Lincoln University, and of course other honors came his way. He was recognized

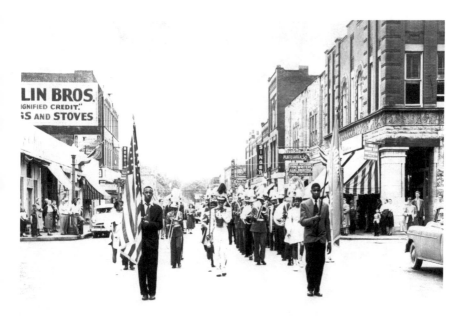

The C.C. Hubbard Marching Band parades through downtown Sedalia (circa late 1940s). *Courtesy of the Collection of Rose M. Nolen.*

all over the state for his dynamic leadership, and for having a school that the whole community was proud of. He wanted the best, he gave his best and he expected the best of his students. He made them believe in themselves. He made his students know that such was expected from them and he never let you forget the fact—that you are somebody. He started in with his first graders, letting them know that you can be somebody—just stay in school and get an education. I can hear him now asking little boys and girls, "What do you want to be when you grow up?" If you did not know or have an answer—then you had committed a crime. He would never let you forget it. With a principal like that, how could you do anything but try to succeed in life? He never ceased to work for the betterment of his people.

He was a great lover of music and personally directed at all times, the chorus, the semi-chorus or any other musical organization of the school. Whenever the Hubbard School Band, of which he was very

Mrs. Dorothy Kitchen had the distinction of being a student, a teacher and finally a principal of Hubbard School. She graduated from the high school in 1931.
Courtesy of the Collection of Lincoln-Hubbard School.

proud, marched, he marched at its head. The chorus under his direction, was well known for its rendition of such familiar selections as "The Hallelujah Chorus" from Handel's Messiah, Nathaniel Detts' "Listen to the Lambs," "Sundown" and many other well-known songs.

I could go on and on telling you of the many things that this great educator did, but time will not permit. However, I am grateful for the opportunity of having been a student of the C.C. Hubbard School from first grade through twelfth. And then grateful for the privilege of returning to Sedalia as a teacher and working under his supervision, for he was a great leader, educator and humanitarian. Whatever success I've achieved I owe it to his teaching, his leadership and his interest in making one believe in himself.

The school motto of just one little word, "Think," was forever embedded in the minds of boys and girls and the song "Invictus," which was sung at each commencement served as the guiding light that was needed to make you want to become the captain of your soul.

[Dorothy Kitchen is a 1931 graduate of Lincoln School. She was also the last principal of the Lincoln Hubbard Elementary School.]

In 1954, when the United States Supreme Court ruled against school segregation in the landmark *Brown v. Board of Education of Topeka* (Kansas) case, it had an immediate impact on all public schools, including those in Sedalia. The process of integrating Sedalia's schools began in 1955. That same year, busing of students from other communities to attend Hubbard ended. In 1956, the first Hubbard students enrolled in Smith Cotton High School. The last commencement exercises to be held in the Hubbard auditorium were held in 1963. The class of 1964 joined the Smith Cotton graduating seniors in commencement held at Jennie Jaynes Stadium. C.C. Hubbard High School was closed in 1967. The building was used by Sedalia School District 200 from 1973 to 1980 as a Special Education Center.

A group of concerned citizens formed an organization called the Lincoln-Hubbard Development Corporation and purchased the school

from the school district for one dollar. When development efforts failed, the group sold the school to local businessman George Pearl. Pearl sought permission to rezone the site for light industry, but when neighbors around the school resisted, he obtained a special use permit from the City of Sedalia and began to dismantle parts of the building for salvage. Ultimately, the elementary school building was torn down.

At an earlier time, in 1980, some former students under the leadership of teacher-musician Gloria Shepard organized the Lincoln-Hubbard Reunion Committee. The group's goal was to promote an All-School Reunion. The first such event was held July 31–August 2, 1981. The idea apparently caught fire because more than five hundred former students and their guests turned up. The group that had hosted the reunion decided to incorporate in October 1984. Mrs. Shepard came up with the idea of placing a monument on the school site. The organization purchased land from Sedalia School District 200. With the help of contributions from some of the alumni, a monument designed by former

This monument, designed by Raymond Taylor, was placed in front of the school by members of the Lincoln-Hubbard Reunion Committee. *Photo by Jeff Smith.*

A plaque listing the names of all the principals of Lincoln-Hubbard stands in the corner of the monument. *Photo by Jeff Smith.*

student Raymond Taylor was set in place on the school property at the corner of Osage Avenue and Johnson Street. The All-School Reunions are held every three years.

A second organization, the Lincoln-Hubbard Alumni Association, was incorporated in June 1989. This group was led by former student Alyce Williams. The alumni association had as its goal a truly ambitious project. The purpose was to preserve and restore the Hubbard school building. They quickly purchased the building from George Pearl in October of that year and began work on creating a neighborhood management center.

With the help of grants, donations and in-kind contributions, the association was able to renovate portions of the grand old building. The remodeled sections were used to set up a library, a programming area and an office. The group organized a drill team of young people who

performed at many local and area festivities and held annual observations of Kwanzaa, Martin Luther King's Birthday celebration and an annual Easter Egg Hunt in Hubbard Park. The accomplishments of the alumni association earned them many state awards and commendations. One of their major achievements was to have the Hubbard High School building placed on the National Register of Historic Places.

Work at the site ended with the death of Alyce Williams on May 2, 2000. Unfortunately, Mrs. Williams did not live to see her dream realized.

Lack of activity in and around the school allowed it to slowly begin to deteriorate. Sedalia's mayor, Bob Wasson, became concerned about the condition of the school and formed a task force to try to find ways to save the building. He appointed a local African American minister, Reverend E.T. Sims, to head the task force.

According to Belva Morney, a member of Diversified Community Outreach (DCO), an organization led by local pastor W.T. Morris, DCO decided to hold a rummage sale as a fundraiser and used the money generated to clean up the site. The task force was able to maintain the building and keep the grass cut into the summer of 2005. At that time, one organization expressed interest in purchasing the building.

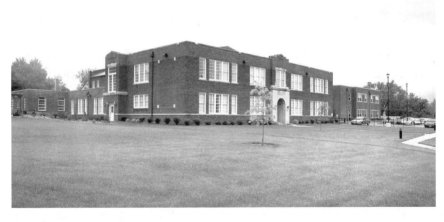

The Lincoln-Hubbard Apartments following renovations of the building by Maco Development Co., LLC, of Clarkton, Missouri. *Photo by Jeff Smith.*

Maco Development Company, LLC (headquartered in Clarkton, Missouri), a company in the business of revitalizing and renovating old historic buildings, took an interest in Hubbard School. The company connected with the DCO group and arranged for them to go to Kansas City and visit a school they had converted into an apartment building, said Morney. Maco met with Reverend Sims and ultimately purchased the building from the Lincoln-Hubbard Alumni Association and began the renovation in 2007.

Since Lincoln school had been demolished by a previous owner, a new addition was added to the high school building, and the two buildings were connected by a glass walkway. The renovation was completed in June 2009 in time for the All-School Reunion, which was held in August of that year.

The newly renovated building contains a total of thirty-nine apartments, nine one-bedroom units and thirty two-bedroom units.

The gymnasium-auditorium has been converted to this community room, which serves as a recreation area for tenants, as well as a meeting place for community organizations. *Photo by Jeff Smith.*

The community kitchen, where tenants prepare meals for meetings and other activities. *Photo by Jeff Smith.*

The scoreboard for the Hubbard Tigers basketball team has been left in the old gymnasium, along with several framed photograph of students and members of the faculty, as a reminder of days gone by. *Photo by Jeff Smith.*

Each apartment has a refrigerator, a dishwasher and a stove, along with a washer and dryer. Tenants, who must be over fifty-five years of age, share a community room, which occupies the old school auditorium gymnasium, an equipped exercise room, a library, a room with computers and a kitchen for special occasions. A gazebo for outdoor activities is located on the property.

From classrooms where academic excellence was the norm to a luxurious atmosphere for gracious living, the C.C. Hubbard building continues to serve the needs of the Sedalia community. It is now more than 140 years old and counting.

NAMES OF STUDENTS WHO ATTENDED GEORGE R. SMITH COLLEGE

Twenty-ninth Annual Bulletin, 1924–1925

ROLL OF STUDENTS (1924)

COLLEGE DEPARTMENT

SENIORS

Buckner, Opal	Sedalia, MO
Chase, Cardell	Sedalia, MO
Cox, Elroy M.	Sedalia, MO
Easton, Jessie L.	Omaha, NE

JUNIORS

Buckner, Overton	Sedalia, MO
Jones, Clara May	Sedalia, MO
Reynolds, George	Sedalia, MO
Rice, Theodore	Sapulpa, OK

SOPHOMORES

Carter, Alice	Rolla, MO
Crouch, Eula	Sedalia, MO
Crouch, Nola	Sedalia, MO

Evans, Mattie — Luther, OK
Guyton, John R. — St. Charles, MO
Smith, Merrill — Sedalia, MO
Thompson, Harry L. — Tulsa, OK
Wrightstell, Perry E. — Mexico, MO

FRESHMEN

Canady, Estella — Sedalia, MO
Carpenter, Dovie — Hughesville, MO
Coates, Genevieve — Sedalia, MO
Couche, Martha — Kansas City, KS
Curtis, William. — Pawnee, OK
Madison, Cecil — Sedalia, MO
McKenzie, Ruth — Sedalia, MO
McDaniel, Theodore — Greenville, TX
Washington, Russel L. — Gilliam, MO

COLLEGE UNCLASSIFIED

Faulkner, Nellie — Fort Scott, KS
Williams, Magnolia — Kansas City, MO

PREPARATORY DEPARTMENT

FOURTH YEAR

Allen, Helen — Oklahoma City, OK
Briggs, E.L. — Chicago, IL
Cave, George H. — Lexington, MO
Davis, Thomas — Little Rock, AR
Gatewood, Curius — Independence, KS
Gatewood, Elaine — Independence, KS
Graham, Charles — Ardmore, OK
McFall, Leroy — Cleveland, OK
Owens, Verona — Independence, MO
Pickett, Andrew — Bude, MS
Washington, Inez — Gilliam, MO

THIRD YEAR

Barnes, George H.	Montrose, MO
Coleman, F.D.	Ojahoma, MS
Eulinburg, Shannon	Jackson, MO
France, Sarah	Foristell, MO
Jefferson, Eli	Greenville, MS
Leasure, Henrietta	Louisiana, MO
Mudd, Blanche	Louisiana, MO
McFall, George	Cleveland, MO
Penn, Bernard	Georgetown, MO
Perkins, Claratina L.	Troy, MO
Proctor, Sylvanus	Independence, MO
Sheperd, Ada	Sedalia, MO
Snell, Borphy	St. Charles, MO
Woods, Jesse	Farmington, MO

SECOND YEAR

Bohannon, Novella	Fulton, MO
Davis, Juanita	Kansas City, KS
Dowd, Delsia	Sulphur, OK
Graham, Eugene, Jr.	Wellsville, MO
Harvey, Beatrice	Sturgeon, MO
Lucas, Birdie	Sweet Springs, MO
Mitchell, Vernita	Davis, OK
Moore, I. Garland	Eufala, OK
Newton, Nannie	Charleston, AR
Smith, Sandy	Kansas City, KS
Washington, Willard	Witchita, KS
Woods, Leafie	Glasgow, MO
Jordan, Andrew	Oklahoma City, OK
Tremble, Mark	Sioux City, IA

FIRST YEAR

Brown, Lorena	Andarko, OK
Cox, Delilah	Purcell, OK
Davis, Thelma	DeSoto, MO
Dowd, Wesson	Sulphur, OK
Davis, Ancel	New Broomfield, MO

Harden, Richard	Webster Groves, MO
Jordan, Ivory	DeSoto, MO
Miles, Tennessee	Kansas City, MO
Moore, Christiana	Fayette, MO
Sims, Andrew	Sulphur, OK

SUB-PREPARATORY

Brown, Nathaniel	Ben Lemond, AR
Raines, Dale	Little Rock, AR
Robinson, Eula	Sedalia, MO
McGowan, Willie	El Paso, TX
Slaughter, Shirley	Los Angeles, CA
Twyman, Elwood	Frankfort, KY

COMMERCIAL DEPARTMENT

SENIORS

Boyd, Armour	Ardmore, OK
Davis, Juanita	Kansas City, KS

JUNIORS

Smith, Claudius	Manhattan, KS
Hackner, Nellie	Mound City, KS
Walls, Theo	Slater, MO
Allen, Helen	Oklahoma City, OK
Saxton, S.J.	Atlanta, GA

HOME ECONOMICS DEPARTMENT

Allen, Helen
Harvey, Beatrice
Lucas, Berdie
Brown, Lorena
Brown, Minnie
Bohannon, Novella
Clark, Dora
Cox, Delilah
Dowd, Delsia
Davis, Thelma
Easton, Jesse

France, Sarah
Gatewood, Elaine
Leasure, Henrietta
Mitchell, Vernetta
Moore, Christina
Mudd, Blanch
Newton, Annie
Smith, Sandy
Washington, Inez
Watson, Dilsy

SPECIALS

Boyd, Armour	Ardmore, OK
Brown, Dorothy	Sedalia, MO
Bryant, Leota	Sedalia, MO
Coates, Arvella	Sedalia, MO
Densmore, Ethylenne	Sedalia, MO
Edwards, Maudelle	Beaumont, TX
Finley, Gerald	Sedalia, MO
Hayes, Murlin	Sedalia, MO
Hayes, Mrs. Robert B.	Sedalia, MO
Hackner, Nettie	Mound City, KS
Jackson, Annie Mae	Sedalia, MO
Jackson, Robert	Sedalia, MO
Jones, Louise	Sedalia, MO
Mallory, Mrs. Dovie	Sedalia, MO
Smith, Claudius	Manhattan, KS
Smith, Dr. O.F.	Sedalia, MO
Simpson, Ethylene	Sedalia, MO
Walls, Theo	Glasgow, MO
Williams, Howard	Sedalia, MO
Watson, Dilsy	Sedalia, MO
White, Virginia	Sedalia, MO

DEPARTMENT OF MUSIC

BEGINNERS—Minnie Brown, Leota Bryant, Maudell Edwards, Elaine Gatewood, Ethylene Densmore, Merlin Hayes, Mrs. Malery, Howard Williams, Ethylene Simpson, Lorena Brown, Louise Jones, Mattie Evans

ELEMENTARY—Novella Bohannon, Blanch Mudd, Nellie Faulkner, Clara Mae Jones, Mrs. R.B. Hayes

ADVANCED—Henrietta Lessure, Dorothy Brown

FIRST YEAR REGULAR COURSE—Anna Mae Jackson, Verona Lee Owens

TROMBONE

BEGINNERS—George Burnes

ELEMENTARY—I. G. Moore, Armour Boyd

ADVANCED—George McFall

SAXOPHONE/CLARINET—Mark Tremble, Andrew Jordan

VOCAL DEPARTMENT

BEGINNERS—Eli Jefferson, Nellie Faulkner

ELEMENTARY—Magnolia Williams

ADVANCED—Clara Mae Jones

VIOLIN DEPARTMENT

BEGINNERS—Dale Raines, Shirley Slaughter, Murlin Hayes, Willie McGowan

ELEMENTARY—Eugene Graham

ADVANCED—Sandy Smith, Gerald Finley

VIOLIN CELLO

Leroy McFall, Charles Graham

COLLEGE ORCHESTRA

VIOLINS—Charles Graham, Sandy Smith, Gerald Finley Eugene Graham, Dale Raines, Shirley Slaughter

CORNETS—Overton Buckner, Theodore McDaniels, Richard Harden

SAXOPHONES—Harry Thompson, Theodore Rice, Robert Jackson

CLARINET—Mark Tremble
SLIDE TROMBONES—George McFall, I.G. Moore, Armour Boyd
CELLO—Roy McFall
DRUM—Jessie Woods

ALUMNI ASSOCIATION

OFFICERS

C.P. Bradshaw, President, 307 North Broadway, Sedalia, MO
Eugene Crouch, Vice President, 213 West Morgan Street, Sedalia, MO
Mrs. Mary Stewart, Secretary, 709 West Cooper, Sedalia, MO
Susie Drake, Assistant Secretary, Marshall, MO
J. Blaine Walker, Historian, 506 South Nineteenth Street, St. Joseph, MO

COLLEGE DEPARTMENT

All college graduates receive the degree of Bachelor of Arts.

1903

Ball, Benjamin, AB, physician, Meharry Medical College, Nashville, TN
Bowles, Pharoah T., AB, plumber, 3118 Lawton Avenue, St. Louis, MO

1906

Bowles, Frank S., AB, pastor, ME Church, Montgomery City, MO

1907

Wright, Reubin O., AB, railroad mail clerk, 2643 Lawton Avenue, St. Louis, MO

1908

Terrill, J. Herbert, AB, principal of public school, Wetumpka, OK
Tompkins, Albert J., AB, principal of public school, Glasgow, MO

1911

Clark, Wyatt A., AB in business, Sedalia, MO
Davis, Nora B., AB, Baldwin, KS
Clark, Bessie L. (Griffin), AB, Sedalia, MO

Jackson, Hattie M. (Smith), AB, New Orleans, LA
Walker, J. Blaine, minister, St. Joseph, MO

1913

Wright, C.N., AB, pastor, Carthage, MO

1914

Wheeler, Gertrude, AB, teacher in public schools, Kansas City, MO

1915

DeMoss, Ora, AB, teacher, Manhattan, KS
Smith, Hazel, AB, teacher, Springfield, MO

1916

Morgan, Grant, AB, BD, pastor, Boonville, IN
McAllister, Leroy, AB, Meharry Medical College, Nashville, TN

1917

Cockfield, Jacob, AB, Meharry Medical College, Nashville, TN
Jeffries, J.H., AB, Sedalia, MO
Lewis, Nettie, AB, teacher, Rust College, Holly Springs, MS
Poston, John, AB, Chicago, IL
Smith, Aurora, AB, teacher, George R. Smith College, Sedalia, MO

1918

Abernathy, Everett, AB, Meharry Medical College, Nashville, TN
Brooks, L.F., ABMD, Sedalia, MO
Smith, O.F., ABDDS, Sedalia, MO

1919

Alexander, Clyde, AB, Meharry Medical College, Nashville, TN
Butler, Payne, AB, Meharry Medical College, Nashville, TN
Grant, L.R., AB, district superintendent, Sedalia, MO
Harrison, Jacob, Gannon Theological Seminary, Atlanta, GA
Meaddough, R.J., dentist, Little Rock, AR
Ratliff, Floyd, AB, Detroit, MI
Watson, H.J., AB, physician, Tulsa, OK
Waynes, B.A., AB, physician, Tulsa, OK

1920

Goins, Berkley J., St. Louis, MO
Jones, William, student, Chicago, IL
Brooks, Ethel H. (Simpson), Sedalia, MO
Smith, Louberta, teacher, Taft, OK

1921

Brooks, Clarencetine, teacher, Jacksonville, FL
Clemmons, Robert L., chef, Morgan College, Baltimore, MD
Nicholson, Willie M., teacher, Salina, KS
Reed, John J., law student, Chicago, IL
Smith, Claudius, Manhattan, KS
Woodson, George C., teacher, George R. Smith College, Sedalia, MO

1922

Diggs, A.E., Sedalia, MO

1923

McClerkin, U.S., Meharry Medical College, Nashville, TN
Reynolds, Alonzo, Meharry Medical College, Nashville, TN
Washington, Phoebe

PREPARATORY DEPARTMENT

1897

*Bowles, Eugene Stanton
*Dillon, Lenora Cornelia
Jackson, M. Miniola, music supervisor, Boley, OK

1899

Abbott, Benjamin F., DD, pastor, Union Memorial ME Church, 208 North Leffenwell Avenue, St. Louis, MO
Hall, Benjamin H., MD, teacher, Meharry Medical College, Nashville, TN
Bell, Nina Zella, AB, '04, Fisk University, Nashville, TN, teacher, Kansas City, MO
Bowles, Phaorah T., AB, '03, plumber, St. Louis, MO
Bridgewater, Robert Tyler, MD, '05, Meharry Medical College, Nashville, TN, physician, Tulsa, OK

Harrington, Benjamin F., principal in public school, Montgomery, AL
Huston, William H., pastor, Curryville, MO
James, A. Lewis, Minneapolis, MN
*Hawkins, Effie J. (Parker)
Williamson, Edgar A., pharmacist, 1014 North Fifth Street, Kansas City, KS

1900

Harvey, Ardonia M. (Abbott), California, MO
*Dorsey, James A., Reverend

1901

Bowen, Myrtle Bessie (Craig), Fulton, MO
Keeton, W. Elmer, musician, St. Louis, MO
Myles, R. Henry, Vernon, LA
Wiley, John W., MD, '04, Illinois Medical College, Chicago, IL, physician, Greensboro, AL

1903

Bowles, Daniel W., lawyer, St. Louis, MO
Brown, Olie U., DDS, '08, Meharry Medical College, Nashville, TN, dentist, Springfield, MO
Fleming, Artee H., West Virginia
Goff, Ward W., Reverend, pastor, ME Church, St. Louis, MO
Rhodes, Arthur, lawyer, Atchinson, KS
Whaley, Mary (Campbell), teacher, Hannibal, MO
*Deceased
*Roberts, Ira G.
*Washington, Stella (Green)
*Whaley, Quintus E., Reverend, pastor, ME Church
*Williams, John T., MD, physician
Harris, Earl A., MD, '08, Meharry Medical College, Nashville, TN, physician, Springfield, MO
Mackey, Luther M., Reverend, pastor, ME Church, Jacksonville, IL

1904

*Goings, Ollie N., DDS, '08, Meharry Medical College, Nashville, TN, dentist
Jefferson, Katherine, New Bloomfield, MO
Terrill, J. Herbert, AB, '08, principal public school, Wetumpka, OK
Tompkins, Albert J., AB, '08, principal school, Glasgow, MO
Wiley, Belle, Topeka, KS

Wright, Reuben O., AB, railroad mail clerk, St. Louis, MO

Brown, Mayme M. (Smith), teacher, Tulsa, OK

1906

Bridgewater, Mattie (Holmes), Tulsa, OK

Davis, George C., law student, Indianapolis, IN

Jackson, Jesse M., lawyer, Washington, D.C.

Jefferson, Garfield G., notary public, Manuel, OK

Williams, George M., railroad mail clerk, St. Louis, MO

Anderson, Luella E., Topeka, KS

Wright, Charles N., pastor, California, MO

1907

Berry, Hattie, 220 North Ming Street, Warrensburg, MO

Brown, John X., Minneapolis, MN

Clark, Wyatt A., AB, '11, George R. Smith College, in business, Sedalia, MO

*Ford, Harry V.O., butler, MO

Clark, Bessie I. (Griffin), Sedalia, MO

Cox, Ellena (Patterson), Parsons, KS

Phillips, Robert

Reeves, H.T., pastor, ME Church, Hannibal, MO

Williams, Adelaide, Leavenworth, KS

Young, Vernon B., Kansas City, MO

1908

Booker, Archie, Waldman's, Sedalia, MO

Davis, Nora B., AB, George R. Smith College, Kansas City, MO

Denny, Lillian, Waverly, MO

Hooks, Hattie T., missionary, Liberia, Africa

Jackson, Otis D., Sedalia, MO

Lane, Zephyr C., teacher, Hannibal, MO

Woodruff, Moss L., 114 Channing Avenue, St. Louis, MO

1909

Jones, Ruth (Buckner), *Denver Star*, Denver, CO

Diggs, Arthur E., graduate, Gammon Theological Seminary, pastor, Sedalia, MO

Martin, Janie, Boulder, CO

Reeves, Caleb B., Boulder, CO

Smith, Raphael B., DDS, '13, Meharry Medical College, Nashville, TN, dentist, Marshall, MO

Smith, Thomas M., '12, Meharry Medical College, Nashville, TN, physician, Chicago, IL

Turner, Percy C., teacher, Nashville, TN

Walker, G. (Young), St. Joseph, MO

1910

Grant, L.R., Reverend, DS, Sedalia District Central Missouri Conference, Sedalia, MO

Vetile, James, railway mail, Denver, CO

Jeffers, Harrison, Sedalia, MO

Turner, Lionel, principal school, Marshall, MO

*Deceased

1912

Wright, Mabel (Cox), Carthage, MO

Dowe, Marie, Oklahoma City, OK

Edgerton, Arthur, Oklahoma City, OK

Harris, Mayo A., physician, Sedalia, MO

McAllister, Leroy, student, Meharry Medical College, Nashville, TN

Morgan, Granville, physician, Nashville, TN

Morgan, Grant, minister, Booneville, IN

Morgan, Freeman, Missouri Pacific Railroad, Sedalia, MO

Sherrell, Joseph C., Jr., Atlanta, GA

Shipley, Galveston I., Tipton, MO

Layne, Gladys, Chicago, IL

Ballance, Hazel, Glenwood, IA

Grant, Hattie, Sedalia, MO

Davis, Pearl, Kansas City, MO

McAllister, Edward L., pastor, Marshalltown, IA

*Villars, Mary, teacher, Frederickstown, MO

1914

Brown, Harrison, lawyer, Wichita, KS

Harrison, Jacob, student, Atlanta, GA

Ratliff, Floyd, Detroit, MI

White, Hogan, Sedalia, MO

1915

Anderson, E.T., minister, Wellsville, MO

Alexander, Clyde, student, Meharry Medical College, Nashville, TN

Butler, Payne, student, Meharry Medical College, Nashville, TN

Broyless, Hiram, student, Chicago, IL
Jones, Wm., college student, Chicago, IL
Steele, P.H., Washington, D.C.

1916

DeBoe, Leroy, St. Louis, MO
Graves, Jason, St. Louis, MO
Goins, Berkley, Elsberry, MO

1917

Crouch, William, musician, Sedalia, MO
Greene, Elbert, student, Chicago, IL
Reid, John, student
Smith, Claudius, Manhattan, KS
Woodson, George, teacher, George R. Smith College, Sedalia, MO
Cox, Elroy M., student, George R. Smith College, Sedalia, MO
Hopkins, Chester, law student, Springfield, IL
Jackson, J.C., minister, Potosi, MO
Reynolds, A.L., college department, George R. Smith College, Sedalia, MO
Washington, Phoebe, teacher, college department, George R. Smith College, Sedalia, MO

1921

Cropp, Ardella, college department, George R. Smith College, Sedalia, MO
Harris, James, Jr., student, Peoria College, Peoria, IL
Rice, Theodore, college department, George R. Smith College, Sedalia, MO

1922

Avery, Myrtle, Windsor, MO
Canady, Herman, Sedalia, MO
Carter, Alice, Rolla, MO
Guyton, John R., St. Charles, MO
McKnight, James, preacher, Holden, MO
Thompson, Harry L., Tulsa, OK
*Deceased
Washington, Ada, teacher, Luther, OK

1923

Decis, A.I., Oklahoma City, OK
Waldon, Katherine, Kenlock, MO
Washington, Russell, Gillum, MO

NORMAL DEPARTMENT

1897

Brown, Sarah Agnes, Ada, OK
*Cotton, Carrie Beulah (Dixon), Chicago, IL
*Langford, Hattie Saphire, St. Louis, MO
*Myers, Gilbert Wendell
Taylor, James Cecil, St. Louis, MO

1888

Bassett, Georgia Clinton (Pringle), teacher, Mexico, MO
Scaries, Maggie Isabelle (Raymond), teacher, Kansas City, KS
Sullivan, Arthur Lincoln, teacher, Byrwin, OK
*Wright, Carrie Sarah
Jordan, Andrew J., physician, Great Warren Hospital, Oklahoma City, OK

1900

Crutchfield, Frances E., St. Louis, MO
Penn, Gertrude Bell, 4210 North Second Street (Hawkins), St. Louis, MO
Porter, Lysetta (Johnson), Kansas City, MO
Johnson, Ida Bell, Belton, MO
Ramsey, Mabel (Nelson), Sedalia, MO

1901

Garvett, Allen H., AB, '19, teacher, Butler, MO
Jackson, Violetta Willene, teacher, public school, Boley, OK
Kibby, Blondelle, trained nurse, Fulton, MO
Miles, William Henry, Gallitan, MO
Palmer, Nellie A., trained nurse, Illinois
Ramson, Helen (Clark), 1183 Lane Street, Topeka, KS
Sharperson, Phoebe (Buckner), elocution teacher, South Grove, MO
Wiley, Allie (Smith), Greensboro, AL

1903

Crosslin, Myrtle E., St. Joseph, MO
Hensley, Bessie E., Chicago, IL
Jones, Addie
McCullum, William W., St. Louis, MO
Patton, John W., Chicago, IL
Stewart, Marie (Diggs), 700 West Cooper, Sedalia, MO
Wilburn, Everett W., railroad mail clerk, St. Louis, MO

1904

Boyd, Ada, Eufaula, OK
Grear, Fred, railway, Sedalia, MO
Hawkinas, Earnest, Kansas City, MO
Johnson, John W., Missouri Pacific Railway, Sedalia, MO
*Price, Oscar B., DDS, '08, Meharry Medical College, Nashville, TN

1905

Washington, Ella, Fayette, MO
Bohannon, Lucy A., Sedalia, MO
Cravens, Maud M., New York, NY
Jackson, Andrew I., Sedalia, MO
Matloch, Retta O., St. Louis, MO
Brown, Mamie M., Ardmore, OK

1906

Bradhaw, Preston C., Sedalia, MO
*Deceased
*Cason, Lucretia (Kruthers)
Brooks, Mae Patterson, Chicago, IL
Reeves, Susie (Barnett), Carthage, MO
Tolson, Annabel (Hill), Fayette, MO

1907

*Cornelius, Norah
Hughes, Fred A., pastor, Redland, CA
Jackson, Edward F., graduate, Gammon Theological Institute, Atlanta,
 GA, pastor, Gonzales, TX
Jefferson, Emma (Booker), Emanuel, OK
Hughes, Ruby, teacher, Lincoln High School, Sedalia, MO
Bruner, May S. (Marshall), Bearden, OK

1908

Abbott, Lou Emma, trained nurse, St. Louis, MO
Bunill, Nellie L. (Burkner), Chicago, IL
Burton, Henry W., teacher, Excelsior Springs, MO
Harris, AB, Warrensburg, MO
Preston, Albert, Reverend, pastor, ME Church, Marshall, MO

1909

Edmondson, Ethel (Ball), Gonzalez, TX
DeMoss, Ora, teacher, Manhattan, KS
Lewis, Nellie, teacher, Rust College, Holly Springs, MS
Graves, Lula (Phillips), St. Louis, MO

1910

Dorsey, Julia, Atlantic City, NJ
Howell, Ethel, St. Louis, MO
Jennings, Leo, Sedalia, MO
Mackey, Augustus, Chicago, IL
Peach, Minnie, Columbia, MO
Poston, John H., Chicago, IL
Pate, Earl, pastor, ME Church, Louisiana, MO
Terrill, Cecillia, Kansas City, MO

1913

Ross, C.R., Jr., Muskogee, OK

1914

Craddock, Tennessee (Abbington), Sedalia, MO
Anderson, Maie, Louisiana, MO
Brown, Mary, Joplin, MO
Berry, Stella, teacher, Fayetteville, AR
Clark, Martha, Louisiana, MO
Browen, Clara (Fry), Wichita, KS
Rowen, Eva, Cape Girardeau, MO
Wyatt, Estella (Martin), Austin, TX
Newbill, S.V., teacher, Lincoln High School, Sedalia, MO

1915

Wright, Mabel (Cox), Sweet Springs, MO
Smith, Bessie (Ball), Marshall, MO
Nasby, Clarence, Jacksonville, IL
Brooks, Ethel (Simpson), Sedalia, MO
Ross, Blanche, teacher, Nelson, MO

1917

Allen, Bernice (Buckner), Denver, CO
Brown, Jesse, undertaker, Wichita, KS

Bohannon, Bernice, teacher, Sedalia, MO
Lucas, Margaret, Kansas City, MO
Matthews, Josephine, Fredericktown, MO

1918

*Deceased
*Chism, Bessie, special, Chicago, IL
Jackson, Myrtle (Farris), Paynesville, MO
Hopkins, Mildred, teacher, Clarksville, MO
Lee, Hazel, student, Howard University, Washington, D.C.
Mecheum, Thelma (Adams), Kansas City, MO
Thomas, Augusta, clerk, Springfield, MO
Vann, McKinley, teacher, Tulsa, OK
Goins, Ida B., teacher, Clarksville, MO
Jackson, M.M., teacher, Boley, OK

1919

Boyd, Alta, housekeeping, Oklahoma City, OK
Burton, Jeannette, Sedalia, MO
Carter, Cecil, teacher, Georgetown, MO
Alexander, Jewell, teacher, Miami, MO
Allen, Shellene (Alexander), Lincoln, MO
Campbell-Shackelford, Julia, Detroit, MI
Cox, Ruth, teacher, Nowata, OK
Diggs, Christina, teacher, Muskogee, OK
Faulkner, Sallie, student, Emporia, KS
McKnight, Myrtle, teacher, Oswego, KS
Penn, Mary, Georgetown, MO
Wallace-Morgan, Carrie, Booneville, IN

1921

Drake, Susie, teacher, Otterville, MO
Mullins, Laura, teacher, Princess Anne Academy, Princess Anne, MD

1922

Peale, Vivian, teacher, Blackwater, MO
Scott, Maud, teacher, Bowling Green, MO
Graham, Chrisella (Turner), Wichita, KS

COMMERCIAL DEPARTMENT

1903

*Ball, Effie V. (West), Nashville, TN
Biggers, Lela, business college, Indianapolis, IN
Biggers, Charles A., principal of business college, Indianapolis, IN
Croslin, Myrtle E. (Carr), St. Joseph, MO
Brooks, S., railroad mail clerk, St. Louis, MO
Wilson, Sarah (Embry), Malta Bend, MO

1904

King, Letha (Bruce), Chicago, IL
Cole, Sadie (Harper), Montgomery City, MO
Parsons, Bertie
Scott, Leola, Kansas City, MO

1909

Burton, Henry W., Kansas City, MO
Webster, Benetta, Coffeyville, KS

1910

Jones, Ruth Buckner, Denver, CO
Burton, Henry W.

1914

Archer, Emily (Jamerson), Chicago, IL
Rivers, Susie M. (Mills), teacher, Philander College, Little Rock, AR
Ball, Ethel, Gonzalez, TX
Jackson, Emma, St., Louis, MO
Thomas, Julia, stenographer, government service, Washington, D.C.
*Deceased
Branwood, Celith, Pueblo, CO

1915

Anderson, Hanna, Louisiana, MO
Sterns, Beatrice, Phoenix, AZ

1918

Brown, Eleanora V., full course teacher, Okmulgee, OK
*Chism, Bessie, typewriting

1919

Greene, Helen M., typist, Chicago, IL

1920

Gibson, Lillie Mae, Riverton, IL

1921

Baskett, Walker, Chicago, IL
Price, Goldie, stenographer, *Kansas City Sun*, Kansas City, MO

1922

Graham, Otis F., Ardmore, OK
White, Virginia, Sedalia, MO
Wrightstell, Perry E., student, George R. Smith College, Sedalia, MO

MUSIC DEPARTMENT

1919

Grant, Mrs. M.M., teacher, private classes, Sedalia, MO

1921

Ritchie, Virgil (Bruner), Shawnee, OK
Carter, Alice, student, George R. Smith College, Sedalia, MO
Jordan, Armeade, student, Fisk Conservatory, Nashville, TN
Meaddough, Miranda, student, Fisk Conservatory, Nashville, TN
Price, Goldie, stenographer, Kansas City, MO

PIANO GRADUATE

1922

Carter, Alice, Rolla, MO

1923

Coates, Genevieve, assistant in music, George R. Smith College, Sedalia, MO

ELEMENTARY ADVANCED

Coates, Genevieve, Sedalia, MO
Watkins, Viola, Sedalia, MO

1923

Walden, Katherine

DOMESTIC SCIENCE AND ART

1919

Diggs, Christine, Sedalia, MO

1922

Coates, Esther (special), Sedalia, MO

Resources

Batterson, Jack A. *Blind Boone: Missouri's Ragtime Pioneer.* Columbia and London: University of Missouri, n.d.

Berlin, Edward A. *King of Ragtime Scott Joplin and His Era.* New York: Oxford University Press, 1994.

Brode, Patrick. *The Odyssey of John Anderson.* Toronto, ON: University of Toronto Press, 1989.

Curtis, Susan. *Dancing to a Black Man's Tune: A Life of Scott Joplin.* Columbia and London: University of Missouri Press, n.d.

Downey, Bill. *Tom Bass, Black Horseman.* St. Louis, MO: Saddle and Bridle, Inc., 1975.

Greene, Lorenzo J., Gary R. Kremer and Antonio F. Holland. *Missouri's Black Heritage.* Revised edition. Columbia: University of Missouri Press, 1993.

Hasse, John Edward, ed. *Ragtime: Its History, Composers, and Music.* New York: Schrimer Books, a Division of Macmillan, Inc., n.d.

Himes, Chester. *My Life of Absurdity: The Later Years.* New York: Paragon House, 1990.

Margolies, Edward, and Michael Fabre. *The Several Lives of Chester Himes.* Jackson: University of Mississippi, 1999.

Nolen, Rose M. *Lost on the Prairie: George R. Smith College for Negroes.* Sedalia, MO: Rosemark Communications, 1985.

Wilkerson, J.L. *From Slave to World-Class Horseman: Tom Bass.* Kansas City, MO: Acorn Books, 1999.

ABOUT THE AUTHOR

R ose M. Nolen is an author and award-winning columnist. She is the author of *Hoecakes, Hambone and all that Jazz*, the story of the customs and traditions of African Americans in Missouri. In 1989, as a columnist for the *Columbia Daily Tribune*, she was named by the Missouri Press Association as the state's best columnist. For several years, she edited and published *Mid-Missouri Black Watch*, a quarterly newsletter serving African American communities. In 2003, she was a recipient of the Governor's Humanities Award for excellence in community heritage. She currently writes columns for the *Columbia Missourian* and the *Sedalia Democrat Times*.